IMAGES
of America

TOWN OF OSWEGO

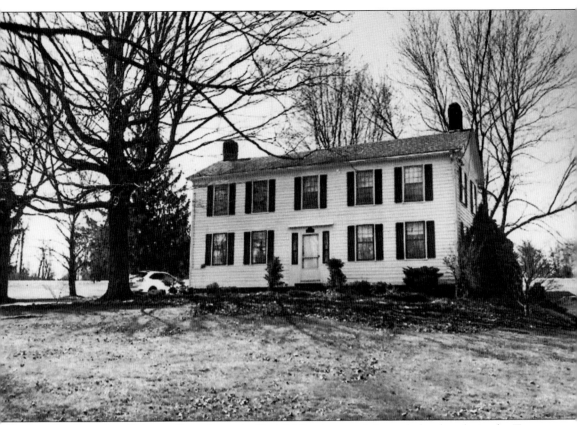

The Daniel and Miriam Pease house in Fruit Valley is one of the early landmarks in the Town of Oswego. The two-story house, which was completed in 1826, was the first frame house in the town. In the back of the house, there was a three-story barn in which slaves hid, as this was a stop on the Underground Railroad. The Peases, well-known abolitionists in Central New York, are buried across the road in Oswego Town Rural Cemetery. (Courtesy of the Town of Oswego archives.)

ON THE COVER: The youth mission band of the Southwest Oswego Baptist Church proudly poses for a group photograph, sitting on the front steps of the church. The picture was taken by Lyman Place in the late 1890s. The Rev. Archibald Sutphin and his wife, Mary, are seated in the midst of the youth. Churches and the district schools were a very vital part of the town's life. Note the collection boxes the children are holding for mission monies. (Courtesy of the Town of Oswego archives.)

IMAGES
of America

TOWN OF OSWEGO

George R. DeMass

ARCADIA
PUBLISHING

Published by Arcadia Publishing
Charleston, South Carolina

Printed in the United States of America

Library of Congress Control Number: 2013950887

For all general information, please contact Arcadia Publishing:
Telephone 843-853-2070
Fax 843-853-0044
E-mail sales@arcadiapublishing.com
For customer service and orders:
Toll-Free 1-888-313-2665

Visit us on the Internet at www.arcadiapublishing.com

*To Tressa Groat King, my grandmother, who gave
me her love for history, and to Benjamin B. Place,
former Oswego town historian and my mentor.*

Contents

ACKNOWLEDGMENTS

Unless otherwise noted, all images in this book are property of the Oswego Town Historical Society and archives. Lyman T. Place paved the way for this book by photographing townspeople beginning in 1898. I wish to thank the many people over the years who have contributed so generously to the archives in pictures and articles. I also wish to thank Remy Thurston of Arcadia Publishing for his expert guidance and advice.

INTRODUCTION

The Town of Oswego was first settled in 1797 by Asa Rice and established from the Town of Hannibal in 1818. Rice, who arrived from Connecticut, traded land with a Revolutionary War veteran whose military tract allotment was west of Oswego, New York. Rice traveled up the Mohawk Valley to Oneida Lake, down the Oswego River to Lake Ontario, and along the shore to the allotment on what is Three Mile Creek (now Rice Creek). Upon arrival, he said, "This is our land." The date was October 6, 1797, about 2:00 p.m. His son, also named Asa, jumped out of the boat and said, "I'll be first to take possession." The elder Rice named the settlement Union Village, but years later it was renamed Fruit Valley because of the prosperous orchards of apples and pears and fields of strawberries. The town is presently 2,633 square miles. The original settlement was somewhat larger, but in 1916, the village of Minetto broke away because of tax issues, forming its own township as the Town of Minetto. The latest census listed the population as near 7,400.

There are three hamlets within the town's boundaries. They are Fruit Valley, Southwest Oswego, and Oswego Center, the latter being the seat of government. Many Irish immigrants came to town in the 1850s and 1860s, especially from Cavan and Monaghan Counties. They settled along Lake Ontario's shore. One of the sons of these immigrants was David Hall McConnell. At the age of 18, McConnell left his father's farm on Lewis's Bluff and founded the California Perfume Company, which later became Avon Products Inc. He effectively introduced the original door-to-door sales method.

Two Town residents—Emma Adams and her sister Marietta Adams Ruttan of Oswego Center—began a cottage industry of doll making. Their dolls were made of cloth with a hand-painted face. These are the famous Columbian dolls, which received their name from the World's Columbian Exposition of 1893 in Chicago, where they were displayed. Today, the dolls have become popular collector's items.

The most prominent of Oswego Town's citizens was Dr. Mary Edwards Walker, born on Bunker Hill on Bunker Hill Road. Her father, Alvah Walker, came from the Boston area and christened the hill and road where his daughter was born, saying that he hoped it would be the site of many battles for reform in education and social justice. His daughter Mary forcefully carried the banner for these issues, as well as suffrage and dress reform. She received her medical degree from Syracuse Medical College and offered her services in the Civil War as a contract surgeon with the 52nd Ohio Volunteers. She was captured and exchanged for an officer of equal rank. For her services, on the recommendations of Generals William T. Sherman and George Thomas, she was awarded the Medal of Honor by Pres. Andrew Johnson on November 11, 1865. Dr. Walker is the only woman to receive the medal.

The pictures that follow show everyday life in Oswego Town through the years, as lived by its people at work and play and in schools and churches.

One

FAITH AND THE THREE "RS"

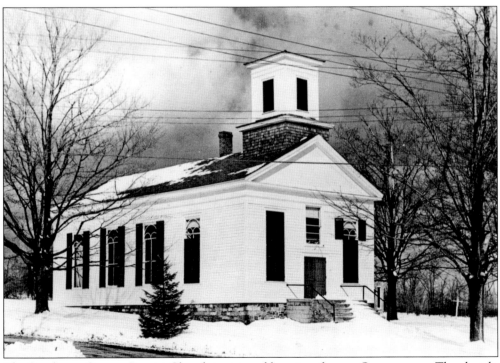

The Southwest Oswego Baptist Church is pictured here in a famous Oswego snow. The church, the oldest in the town, is located at the intersection of State Route 104 and County Route 20 (California Road). This view was taken in the winter of 1950 by the pastor at the time, the Reverend Luther Bunting. He was a professional photographer as well as a minister. The church sits on a hill and is known as "the lighthouse on a hill."

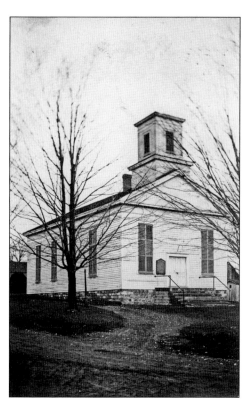

The Baptist church was organized in 1839 after an African American man passed through the area holding meetings. Its building was erected in 1852. The congregation had initially met in a building just south of what is Ontario Orchards today. It was called "the Tabernacle." One of the builders of the church edifice was Stephen Cobb, Southwest Oswego's first blacksmith. This view of the church is from the early 1920s.

This is the only known picture of one of the town's early pastors, the Rev. Isaac Butterfield, in the 1850s. He also served the West Baptist Church in the city of Oswego. Just over 40 pastors have served the congregation since its founding in 1839.

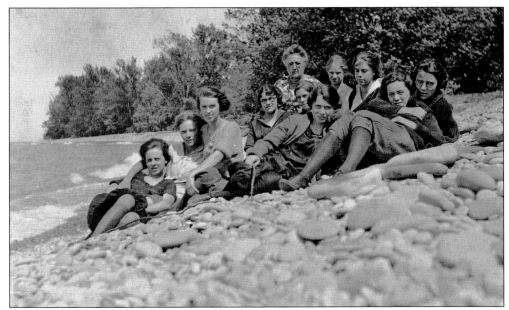

The churches in town were centers of many social gatherings. Seen here is a young ladies' Baptist Sunday school class camping at Simmons Grove on the West Lake Road in 1923. From left to right are (first row) Edna Simmons, Ruth Gerhart, Letty McGlen, Laura Tice, and Mary Post; (second row) Lucy McGlen, Hilda Wallace, Bertha Wallace, Ruth Griswold, and Evelyn McGlen; (third row) teacher Evadell Darrow.

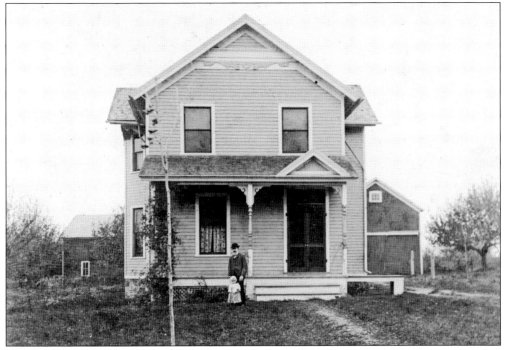

The Southwest Oswego Baptist Parsonage was built in 1891 with a generous gift from one of its members, Sally Deming. This image was captured in 1901 by Lyman Place. The pastor, Rev. F.E. Brininstool, stands with his daughter in front. Both the house and garage are in use today.

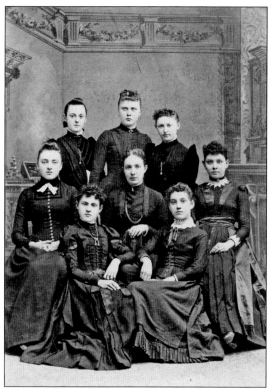

In this 1890s photograph, the women's Sunday school class poses in a studio. They are, from left to right, (sitting) Nellie Martin King, Maude Kennedy, teacher Elizabeth Edwards (holding Bible), Edith Holmes, and Jennie Sabin; (standing) Florence Rowe, Elsie Edwards Tice, and Clara Rowe.

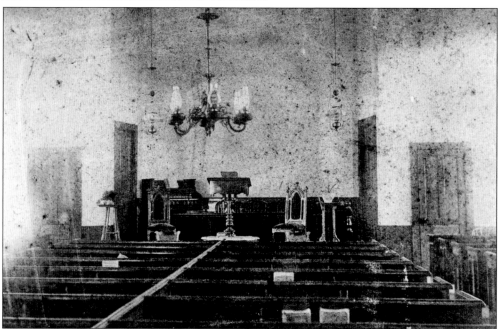

This 1890s interior view of the Baptist church shows the quite ornate pulpit in the center, as well as the pump organ at left. The baptistery would be in the floor behind the curtained rail. Note there is no center aisle. There are two caned chairs on each side of the marble-top communion table. The ceiling is made of tin.

Rev. Rudolf Unger and his wife, Prudence, served the church from 1937 to 1941. Reverend Unger was an artist and painted a three-dimensional cross in the center of the chancel. The Ungers served during the church's centennial in 1939. One of the projects of that anniversary was photographing the individual families at their homes and farms. Reverend Unger took the pictures as slides, a new and creative process for 1939.

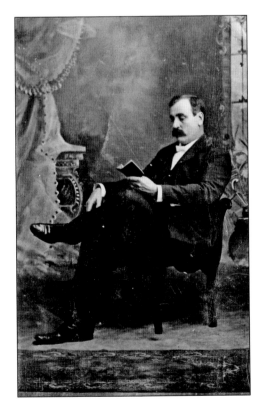

Rev. John C. Murphy, pastor from 1908 to 1911, poses for his picture. Reverend Murphy was also a blacksmith and is said to have added some interesting "color" to his preaching, speaking in plain and common language.

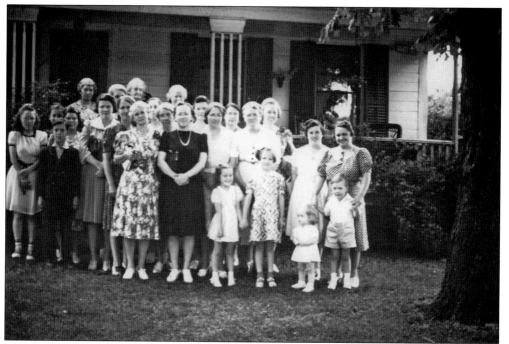

Rev. William D. Corbin, affectionately known as "Elder Corbin," served the Baptist church from 1869 to 1875. He retired because of ill health and spent his time in Oswego until his death in the early 1900s. Elder Corbin would be seen visiting his parish while carrying a milk pail. Part of his salary was given to him in food goods from the parish farmers. A few in the community still remembered him into the 1950s.

The Baptist Ladies Aid Society met for a centennial picture at the home of Grace Simmons in 1939. The house is located on the corner of State Route 104A and the DeMass Road. Prudence Unger, the pastor's wife, stands at left in the first row with her son Daniel.

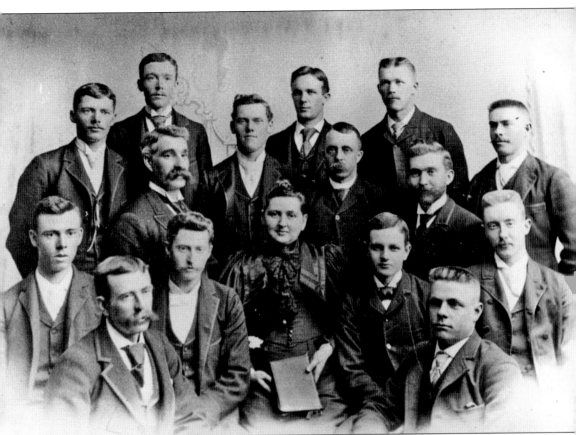

The men's Bible class gathered for their picture day in the 1890s. From left to right are (first row) Bert Miller, Fred Newell, Bert Case, teacher Mattie Pasko, Bert Eaton, Herbert Tice, and Will Pritchard; (second row) Ben Hutchinson, Byron Stewart, Roselle Abbott, Frank Rounds, Reverend Brookins, and A.L. Tice; (third row) Will Andrews, Spencer Brownell, and George Campbell. Pasko is prominently displaying the Bible. At this time, it was unusual for a men's class to have a female teacher.

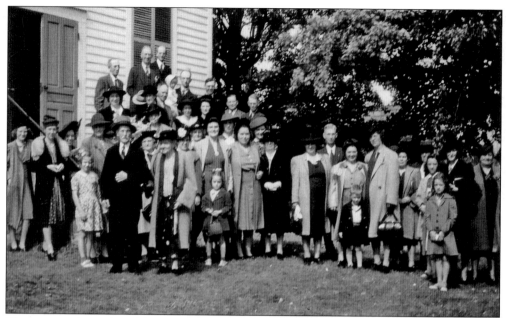

The congregation gathered for a centennial picture in 1939 in front of the Baptist church. "Grandpa" Frank and "Grandma" Ada Eaton, the oldest members at the time, stand in front. The church had much to celebrate. One note of distinction is that it was a driving force in the national Sunday school movement of the 19th century. One of the church's members, John B. McLean, was one of the movement's early leaders. McLean is buried in Oswego Town Rural Cemetery.

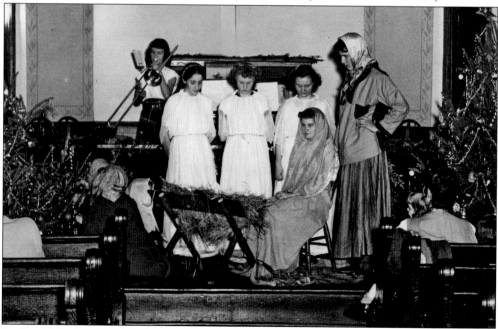

In this 1949 photograph, Christmas is celebrated with a live Nativity scene. Marlene DeMass plays the trombone. The angels are, from left to right, Mary Bunting, unidentified, and Florence Hutton. Mary Simmons plays Mary, and David Bunting is Joseph. The pastor's wife, Edna Bunting, sits in the pew to the right.

Another outing for the Baptist congregation was this Sunday school encampment at the Thousand Islands in the 1890s. The Thousand Islands are located in the St. Lawrence River in Upstate New York, 70 miles from the church. It was quite a journey in those days. Rev. Archibald Sutphin is seated on the ground at the left. Mary Sutphin sits in the chair behind him. Evadell Darrow, a Sunday school teacher, is in the chair next to her. The young lady in the white dress on the ground is Frank Martin Tice. Next to her is Elsie Edwards Tice. On the grass behind her is Carrie Newell Brownell and Spencer Brownell in his straw boater. The man standing by the porch is Byron Stewart.

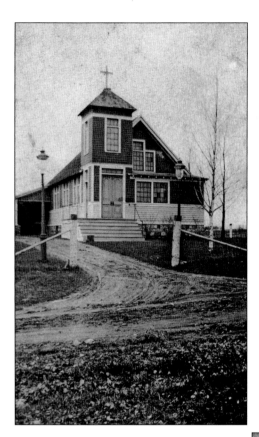

The first Roman Catholic church in town was St. Joseph Chapel, dedicated in 1911. This is an early view with the horse sheds in the back. The road, now named Chapel Road, eventually took its name from the chapel.

St. Joseph Chapel was started as a mission of St. Mary's parish in Oswego under the direction of Rev. Joseph A. Hopkins. Reverend Hopkins envisioned a ministry in town and helped that vision to be realized. He was a beloved pastor of St. Mary's for many years.

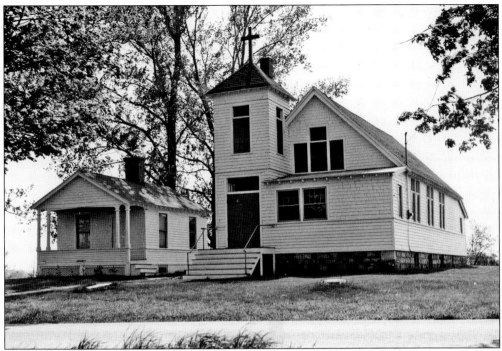

A later view of the chapel shows the road now paved, the horse sheds removed, and a small rectory by its side. The chapel's annual strawberry festival was enjoyed by the whole community.

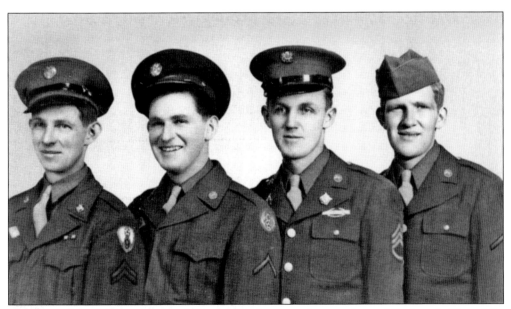

Members of the Malone family of Chapel Road were active members of St. Joseph Chapel for many years until it closed. Here are the Malone brothers, all proud veterans. From left to right are Raymond, Leo, and Bernard, who all served in World War II, and Donald, who served in the Korean War.

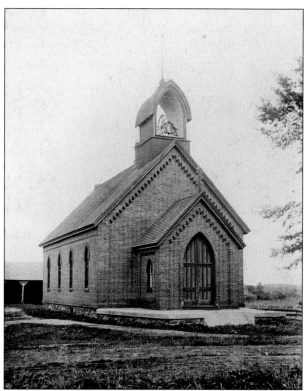

The Methodists came to the area in the early 1800s in what is now the town of Minetto. Recently, the First United Methodist Church of Oswego moved into the town but the two earliest Methodist churches—the Southwest Oswego United Methodist Church and Oswego Center United Methodist Church—are active today. This photograph of Southwest Oswego United Methodist was taken by Lyman Place in 1897. The congregation was organized in 1872 and the brick edifice was built and dedicated in 1874.

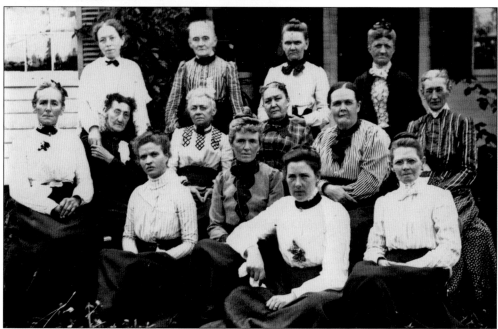

The Ladies Aid Society of the Southwest congregation gathers for a picture. From left to right are (first row) Anna Cronkite, Frances Lewis, Edna McBride, and Delight Rhoades; (second row) Mrs. Campbell, Sarah Randall, Mrs. Jerritt, Mary Jane Groat, Mrs. Himple, and Sarah McManus; (third row) Sarah Fitch, Dorcas Miller, Mrs. Ball, and Mrs. L. Rhoades.

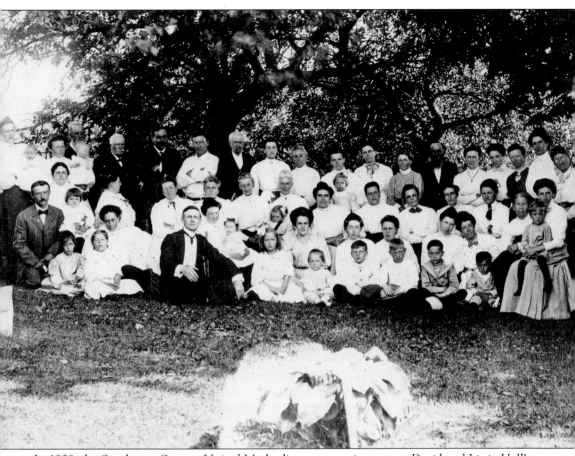

In 1909, the Southwest Oswego United Methodist congregation met at David and Lizzie Hall's home on the Hannibal Road for a group photograph. The Halls were Irish immigrants from the Cootehill area in County Cavan. Among those pictured in the first row are Callie French, Helen Randall, Ethel Miller, Fannie French, Rev. Locke, Edith Place holding Bernice, Isabel Groat, Rita Ireland, Laura Rogers, Hattie Place, and Jennie Tice. The six children in front are unidentified. In the second row are, from left to right, Edith Allen holding Frederick, Sate Deming, Olive McCoy, Maggie Groat, Lot McManus, Mate Miller holding Emma Place, Hattie Place, Mrs. Locke, Nell Tice, Nell McCoy, Hattie Ireland, unidentified, and Ada Lewis holding Harry. Standing in the third row are, from left to right, Luella Randall holding Roger, Martha King holding unidentified, Wendell Wiltsie, Will Rounds, unidentified, Fred Allen, Chester Randall, Sarah Randall, Jennie Campbell, Nellie Place with Marian, Jennie Deming, Lizzie Hall, David Hall, Minnie Martin, Maggie Daly, Neva Tice, Line Loomis, and Flora Rhoades.

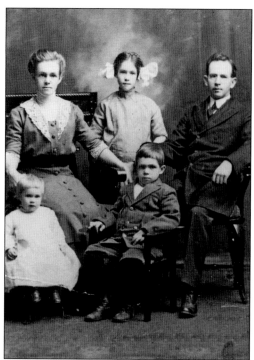

The Southwest Oswego United Methodist Church was one of a two-point charge; the other being the Oswego Center United Methodist Church. They shared pastors. Rev. Alonzo Hand served both churches during World War I. He is pictured here with his family in a formal setting.

Rev. Edward Hannay came as pastor of both Methodist churches in 1949. The reverend and his wife, Ninnie Hannay, seen here with their twins John and Mark, were beloved by the congregation. Reverend Hannay built up the youth program in Oswego Center during his ministry.

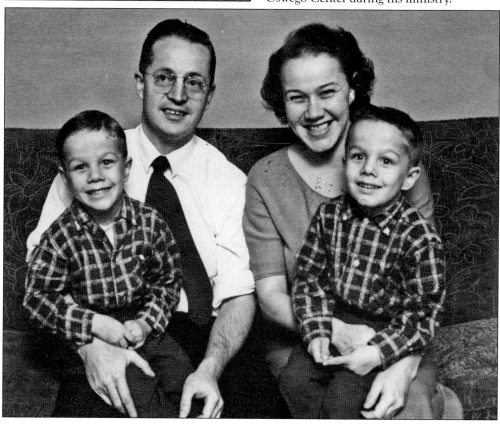

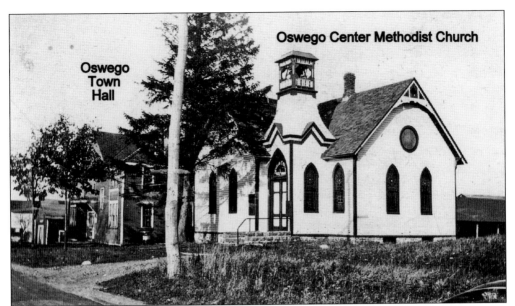

The Oswego Center United Methodist Church building was erected in 1892 along with the Oswego Town Hall. Charles Winkie was the mason who laid the foundation, and the builders were Ira, William, and Frank Rounds and Bert Cole. The first trustees were Sumner E. Metcalf, George W. Baker, and Nathan W. Sabin. Rev. Jabez Stallwood was the first pastor to serve the church.

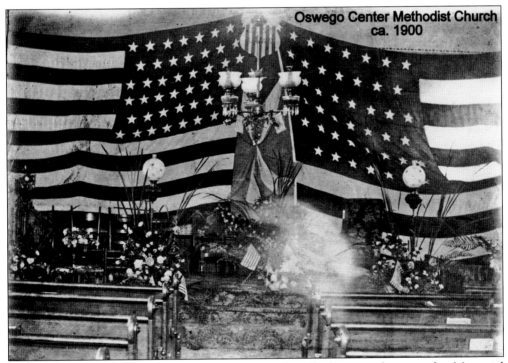

This c. 1900 interior image of Oswego Center United Methodist was taken on either Memorial Day or the Fourth of July. Note the carpet leading to the altar and the beautiful globed kerosene lamps on either side, as well as the hanging lamp in the center.

Both Methodist congregations joined at the Oswego Center Methodist Church in July 1949 to welcome Rev. and Ninnie Hannay in the church hall. From left to right are Mildred Johnson (at the piano), Arthur Neild, Dora Neild, Louise Cooper Kellog, Ron Archambo, Merton Cronkite, Margaret Cronkite, Thelma Johnson, and Helen Place.

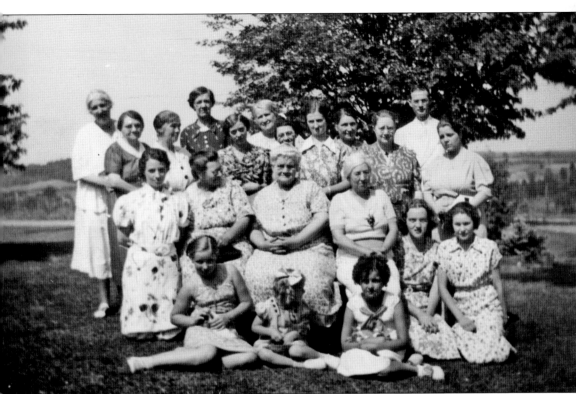

Women of the Oswego Center Church gathered for a summer's outing around 1939. Pictured from left to right are (first row) Ann Leadley, May ?, and Polly Graham; (second row) three unidentified women, Belle Thompson, Jean Brown, and Lola Burton; (third row) Mary Shellhammer, Emma Bareham, Rena Mitchell, Nellie Hersch, Anita Pelton, Lizzie Sabin, and Beulah Cody; (fourth row) Edith Graham, Lorena Jeffrey, Anna McBride, Frances Leadley, and Rev. Ray Cody.

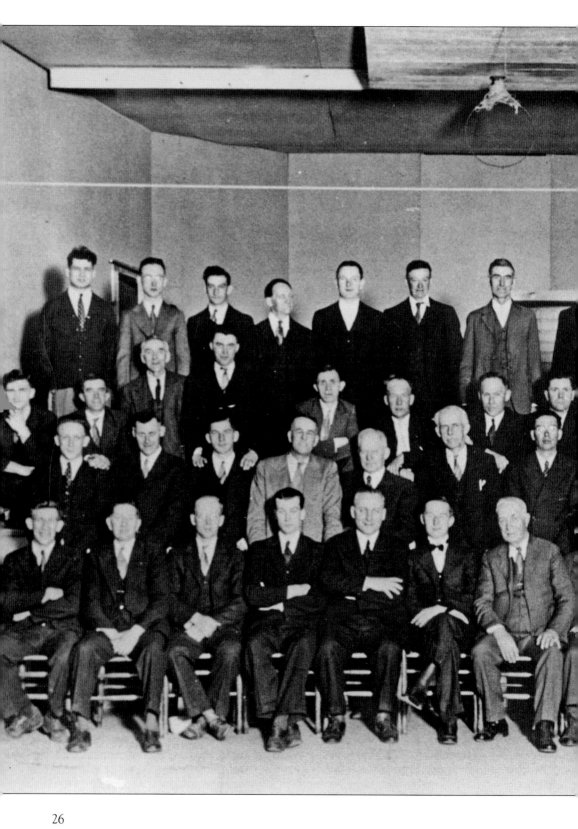

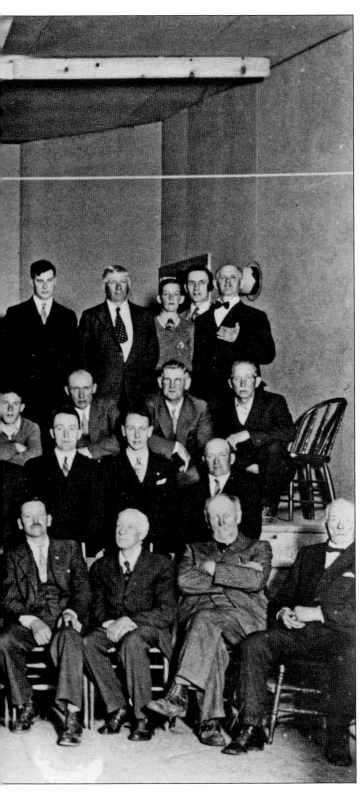

In May 1935, the men of the Oswego Center United Methodist Church gathered in the church hall for this formal picture. From left to right are (first row) George Johnson, Rev. George Wiesen, Milfred Baldwin, Amos Horton, Rev. Walter Suits, Rev. Erwin Bennett, Fred Sabin, Ernest Jenkins, Myron Babcock, Arthur Todd, Nelson Thompson, and Henry Jeffrey; (second row) Cecil Johnson, Floyd Wood, Clifford Petersen, Stanley Graham, Peter Vercrouse, Melvin West, Henry Babcock, Leroy Johnson, John Freemantle, William Wood, and Cleve McLaughlin; (third row) Earl Frye, Albert Laurent, Roy Naracon, Raymond Laurent, Bert Bareham, Frank Hollenbeck, Orville Johnson, Reuel Todd, Wesley Johnson, Charles Leadley, and Walter Phillips; (fourth row) Clarence Mitchell, Clifford Pelton, Kenneth Mitchelson, Ed Metcalf, Pete Cooper, Fred Mitchelson, Mr. Bigelow, Brace Stevens, Asa Laurent, Mr. Mitchell, Dick Babcock, Herb Tanner, and William McLaughlin.

The Town of Oswego had at least 13 school districts, each with its own schoolhouse. Most of the schoolhouses had one room, but some had two. There were plenty of opportunities to learn the three "Rs"—reading, writing, and arithmetic. This little red schoolhouse is on the West Lake Road, formerly No. 9 Road, taking its name from the school district, No. 9. The school was later changed to No. 4. The first building was a log cabin, and the first teacher was Susan Newell. The edifice pictured here was built in 1888 and painted yellow with brown trim. It closed in 1917.

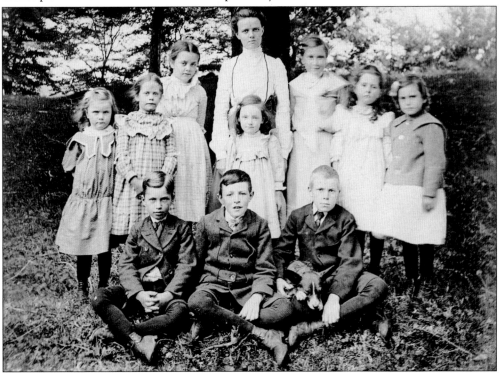

Pictured are students of the No. 9 school around 1903. Standing second from left is Luella McConnell Dudley followed by Vernice McConnell Glerum and the teacher, Nellie Ball, at rear center.

The District No. 12 schoolhouse was located in Southwest Oswego. It was built in 1865 at a cost of $767. This picture was taken in the early 1950s. In the front portion of the school were the cloakrooms, with the girls' coats on one side and the boys' on the other. Outhouses held the toilets. The girls' toilet was attached to the back woodshed, and the boys' was down the lane. Note the school bell on the rooftop. The school closed in 1956.

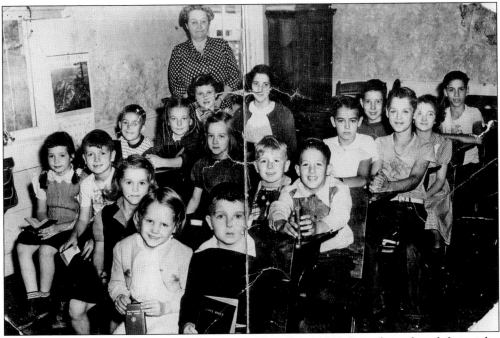

These students are happy to have their picture taken about 1949. Seated are, from left to right, (first row) Cathy Zagame, Dave Longley, Jean Loomis, Rosemary Loomis, and Terry MacLennon (holding a Bible); (second row) John Sullivan, Carolyn Bailey, Carol Ferguson, Henry Kandt, and Joe Zagame; (third row) Carolyn Bond, Mary Bunting, Lester Crowell, and Charles Loomis; (fourth row) John Bunting, Virginia Bond, and Robert Loomis. Teacher Mary C. King stands in the rear.

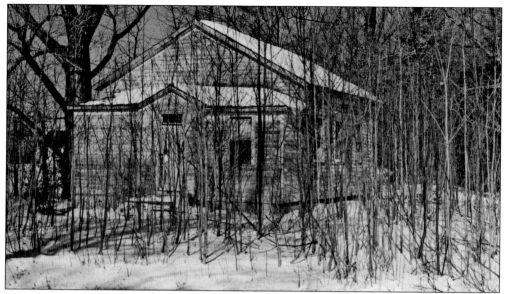

District No. 1, or the California Road schoolhouse, is pictured here years after it closed in 1956. This school was established in 1855, and Alice Guertin was its last teacher.

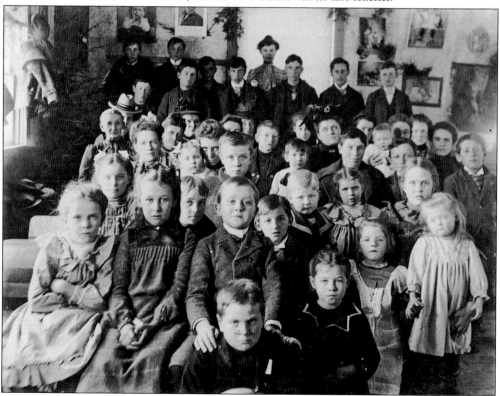

Students gather to celebrate George Washington's birthday in 1901. Lyman Place took the photograph. Student Dewitt Groat, sitting in the very front, appears to be unhappy about being there. The teacher, Mary Donovan, stands toward the back in the center. There is a picture of President McKinley on the wall in the upper left; he had been assassinated in September of that year.

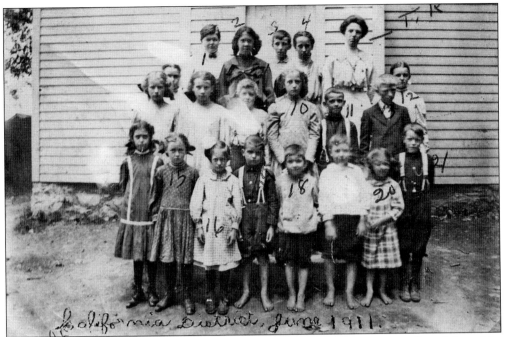

The students in this June 1911 photograph are ready for their summer vacation. From left to right are (first row) Helen Randall, Mary Mahaney, Marjorie Baker, Lester Walrath, Dorr Harrington, Lester Pritchard, Dora Walrath, and Lee Simmons; (second row) Eva Simmons, Jennie Walrath, Ella Irwin, Roger Pritchard, Grace McManus, Homer Walrath, Willis Rhoades, and Amanda Shortslef; (third row) Milton Pritchard, E. Irwin, unidentified, Kate Hinman, and teacher Tressa Thompson. This was Thompson's first teaching job.

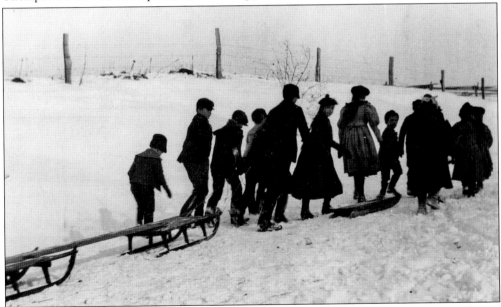

Students climb Place's Hill on California Road, going up to the schoolhouse. Dewitt Groat brings up the rear, and his older brother Charles is directly in front of him. This c. 1898 picture was taken by Lyman Place.

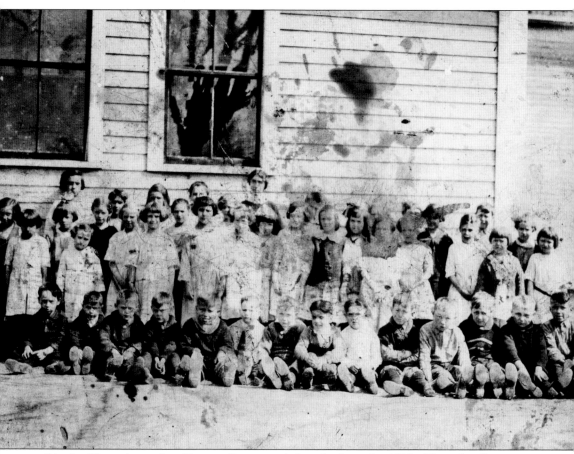

District 10 was located in Oswego Center and dates back to the 1830s. The schoolhouse was initially one room but was later was converted into a two-room building. It closed in 1950. The student body gathers for its group portrait in 1922 or 1923. From left to right are (first row, seated) Walter Winkie, Paul Mahaney, Bill Knopp, George Mahoney, John Zayown, Dave McCann, unidentified, Jimmy Piazza, Dominick Piazza, unidentified, Bill Kubis, two unidentified, and John Czerow; (second row) Florence Ruttan, Rose Zayown, Betty Czerow, unidentified, Gladys Fry, Dorothy Doyle, Edna Hull, Pauline Jadus, Josephine Piazza, Helen Todd, Mamie Mitchell (wearing a bow), Lucille Cooper, Clara Munski, Hilda McBride, Viola McLaughlin (wearing glasses), Mildred Todd, Mary Scozzari, two unidentified, Genevieve Wood (wearing a bow), and Betty Knopp; (third row) Beulah Hull, Beatrice Kandt, Hazel Elbrow, Laura Czerow, Helen Stubnick, teacher Mabel Jenkins, Robert Knopp, and three unidentified.

Two

LABOR AND LEISURE

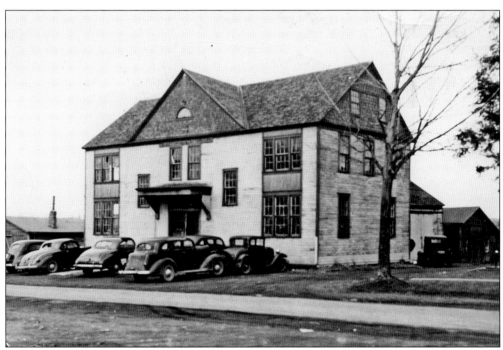

The seat of government for the Town of Oswego is located in the hamlet of Oswego Center. Formerly known as Fitch's Corners, it was changed to Oswego Centre in 1867. The first town hall was built in 1892. Since the founding of Oswego in 1818, the town board met in schools or homes. This is the edifice in the early 1900s. The town sheds that store road equipment are behind the building.

In 1966, a new town hall was built on the site of the earlier structure. The highway garage was expanded to accommodate the road equipment, including snowplows. Offices for town officials were now housed here. Previously, the offices of the supervisor, town clerk, tax collector, and justice of the peace were in the elected individuals' homes.

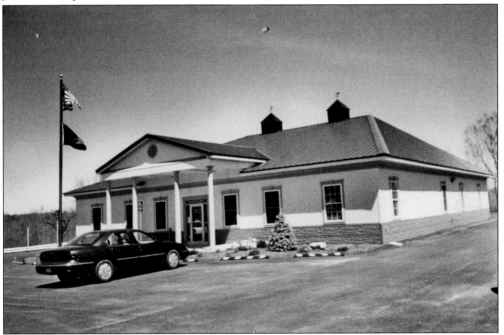

Almost 40 years later, the present town hall was erected on the site of the previous halls, under the leadership of supervisor Victoria Mullen, the first female supervisor of the town. Offices are located here, and it also serves as the home of the Town of Oswego Historical Society.

Attorney Spencer Brownell was supervisor from 1916 to 1924. He and his wife, Carrie, owned and operated a large and prosperous fruit farm in Fruit Valley. There were orchards of apples, pears, and sour and sweet cherries and fields of strawberries. The farm is still producing today under new owners. During Brownell's administration, there were 3,791 registered automobiles in Oswego County. An abandoned road in the town is named after him.

Reuel M. Todd, owner and operator of Todd's Cider and Vinegar Works in Oswego Center, served as town supervisor from 1934 to 1941. He was appointed by the town board when a tie vote occurred at election. Todd also served later as Oswego County Republican commissioner of elections for many years. Under his administration, a water district was formed in 1934.

Victoria Mullen, the only woman to date to hold the office of town supervisor, has served since 2002. Under her leadership, a new town hall and highway garage were built. The Oswego Town Park was established next to the town hall.

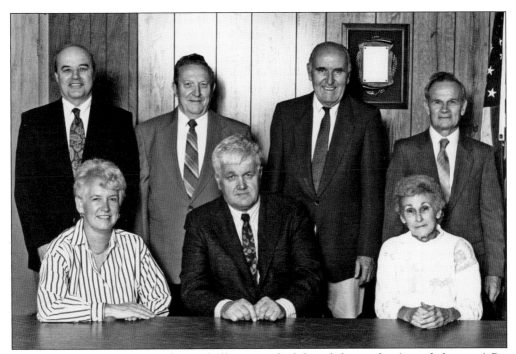

The town board in the second town hall consisted of, from left to right, (seated, first row) Pat Jung, supervisor Dave White, and Elsie Oleyourryk, the first female town clerk; (second row) Roger Wells, John Dibble, Herbert VanSchaack, and Fred Lockwood.

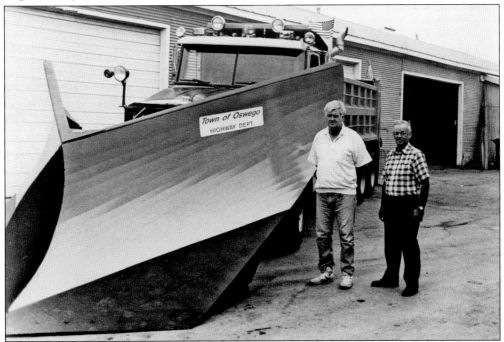

Supervisor Dave White and superintendent of highways John Glerum proudly display a new snowplow. The area's winters are often harsh with much snow, and many hours are spent keeping the roads clear and passable.

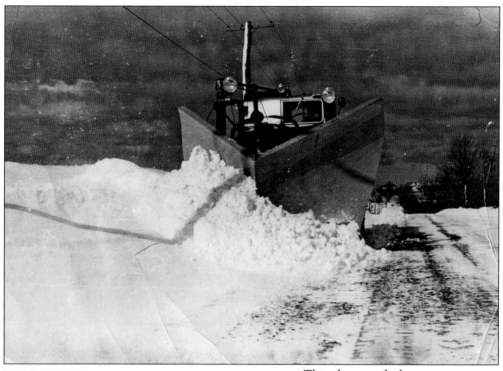

This photograph shows one of those winters in early 1950. Superintendent of highways George DeMass is behind the wheel of the plow, traveling south on County Route 7 (Johnson Road). The picture was taken by Rev. Luther Bunting.

Nelson Gibson Thompson, a local printer and Oswego town clerk from 1919 to 1944, was the longest-serving town official. Thompson had a print shop in Southwest Oswego and later moved to Oswego Center. Many birth, death, and marriage certificates bear his name.

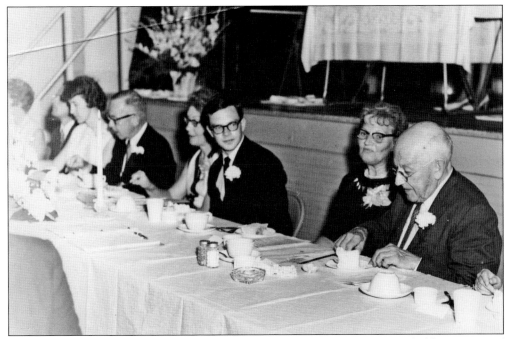

In 1968, the town celebrated its sesquicentennial. A weekend of events was held in August of that year, including a formal banquet in the Oswego Center United Methodist Church hall. At the head table are, from left to right, supervisor Fred Lockwood, Grace Lockwood, assemblyman Edward Crawford, Margaret Crawford, George R. DeMass (co-chair), Florence Dennler (co-chair), and Fred Wright, the oldest guest that evening.

The town board seems happy to have their picture taken in the early 1960s. From left to right are (seated, first row) Donald Kelly, Elsie Oleyourryk, Isabelle Engle Fletcher, and supervisor Fred Lockwood; (second row) Robert Dunsmoor, Lyle Hutchinson, and Charles Sabin.

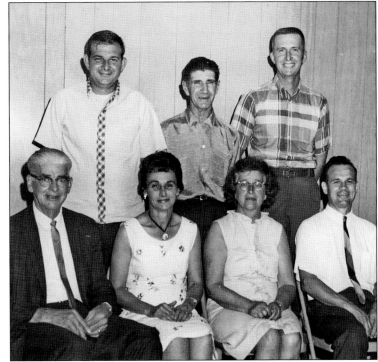

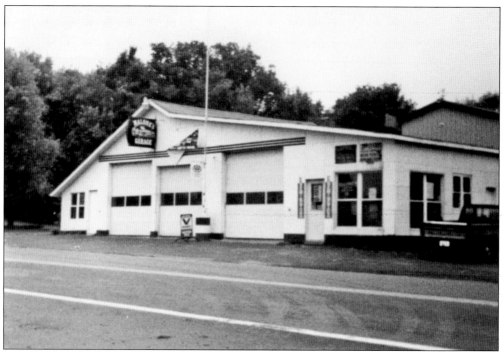

The oldest continuous business in Oswego is Malone's Garage, seen here. It is located in Southwest Oswego on State Route 104 near the intersection with State Route 101A. The business was established in 1938 by Raymond Malone.

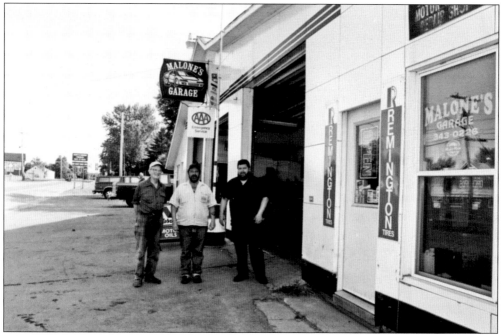

After World War II, Raymond Malone's brothers Leo and Bernard owned and operated the full-service garage. From left to right are Leo, his son Douglas (the present owner), and son Tim. In the background is State Route 104 A.

Muck farming has been a staple of the town's economy for decades. Crops of onions, potatoes, lettuce, carrots, and celery have been grown by quite a few farmers over the years. Norman Simmons's muck land on Tug Hill and State Route 104 is shown here in the 1940s.

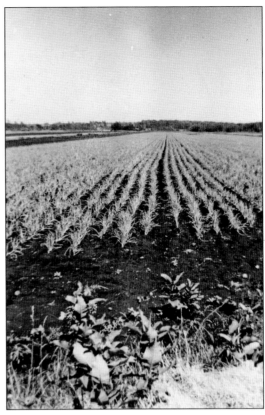

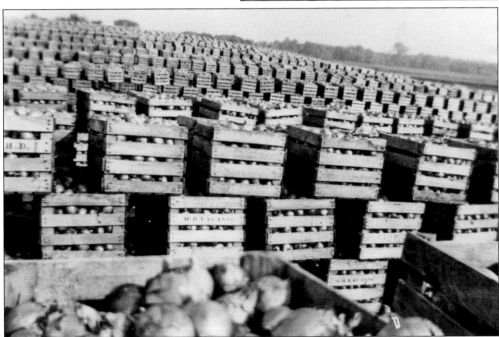

The onion crop is ready for shipment and market. Oswego County lettuce was also well known in New York City markets before it was more profitable to grow and ship it from the West.

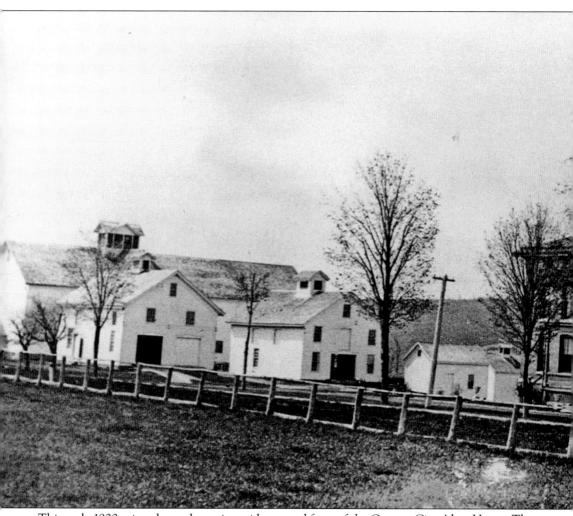

This early 1900s view shows the main residence and farm of the Oswego City Alms House. The institution was somewhat self-sufficient with a dairy. The farm provided a place for residents to

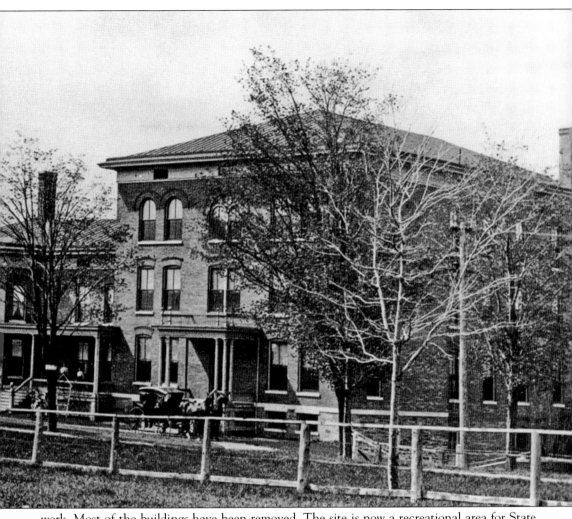

work. Most of the buildings have been removed. The site is now a recreational area for State University of New York (SUNY) Oswego called Fallbrook.

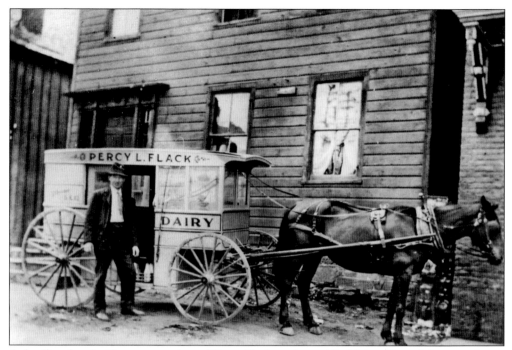

A familiar face in Oswego was that of Percy Flack, as he peddled his milk and dairy products. Flack was one of many dairy farmers in the town delivering their milk, butter, and eggs from door to door. He had a farm in Oswego Town from 1899 to 1918.

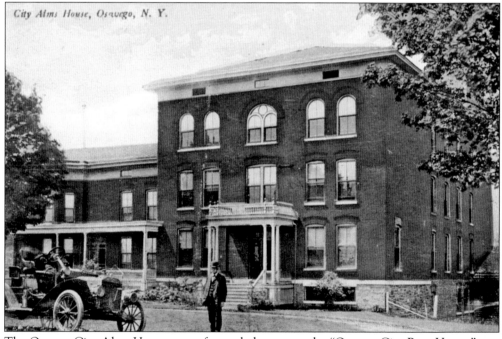

The Oswego City Alms House, more famously known as the "Oswego City Poor House," was located on Thompson Road. The institution was part of the town's life for many years, housing the indigent and homeless. This early-20th-century postcard shows the main building.

Lockwood's Store, operated by Fred Lockwood, was the last general store in Southwest Oswego. It closed in 1959. Previous owners included the Barstow family and Howard Cole, among others. The first store in Southwest Oswego was established by Asa Watson in 1844. In this picture from 1959, Lockwood's mother pumps gas.

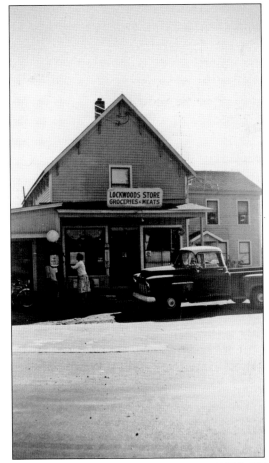

Ontario Orchards, owned and operated by Dennis and June Ouellette, now occupies the former site of Lockwood's Store. It began in the 1960s and serves not only the Oswego community, but also much of Central New York. It is at the intersection of State Route 104 and 104A.

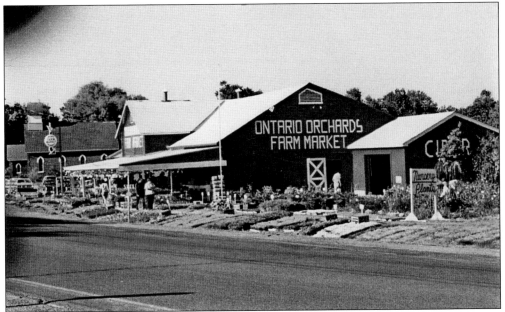

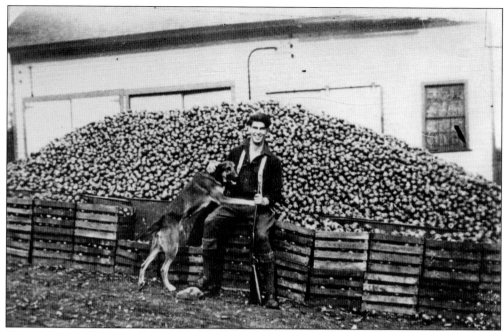

One of the town's cider mills was owned and operated by George Ruttan of Oswego Center. It was established by his father, William. Here George sits with a lot of apples, ready for the processing of that sweet autumn nectar, around 1925.

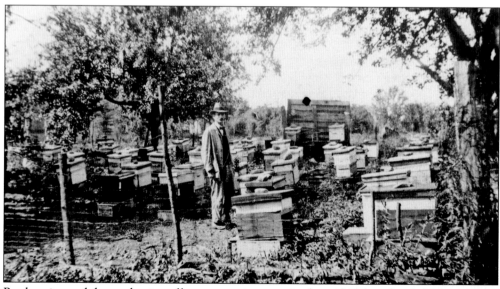

Bee keeping and the production of honey were common in the mid-19th and early 20th centuries in the Oswego Town area. Here is Judson Simmons in 1933 in Southwest Oswego with his 100-plus colonies of bees. Simmons also operated a cheese factory on California Road.

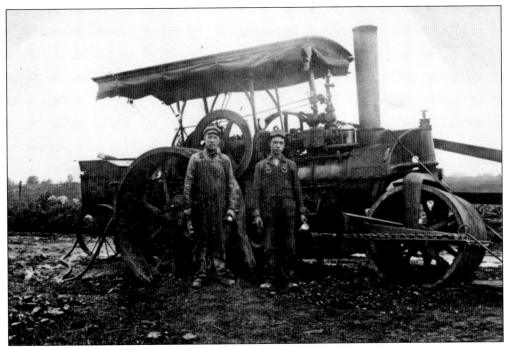

In 1912, the town paid 45¢ per hour for teams of horses and 17.5¢ per hour for men to work on the roads. This was the Oswego steamroller around 1900. (Courtesy of the Bradway collection, Town of Oswego archives.)

Farmers helped each other during harvest times and filling silos. This c. 1899 image is of a steam engine on a Southwest Oswego area farm. The men are unidentified.

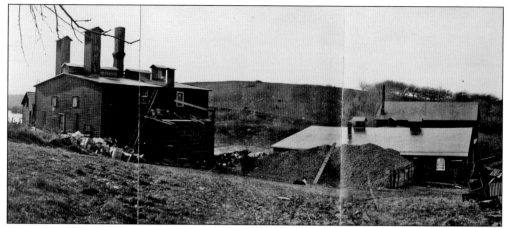

The Place Brothers Cider and Vinegar Works was located on Eight Mile Creek at the end of California Road in Southwest Oswego. Brothers Fred and Ben Place were the owners and operators. This shows the factory in about 1898. Note all the apples.

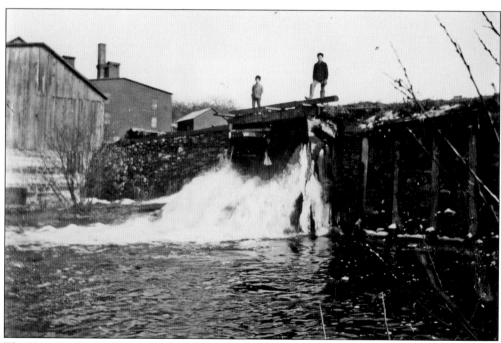

The Place Brothers mill is in the upper left, with the dam of Eight Mile Creek toward the center. The two figures are unidentified, and the dam and mill are gone now—only the millpond remains.

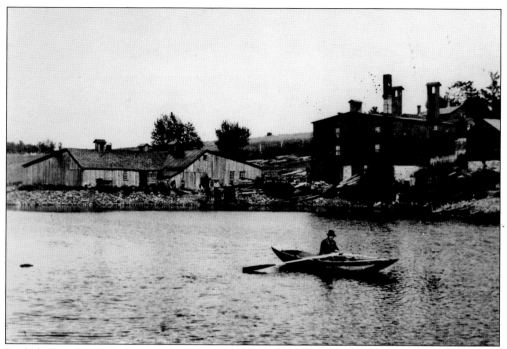

Fred Place is aboard the boat on the millpond. The cider and vinegar works are in the background. Note the fence posts along California Road in the center, along what is known as Place's Hill. The roof of one of the Place houses, adorned with a chimney, is seen in the upper right.

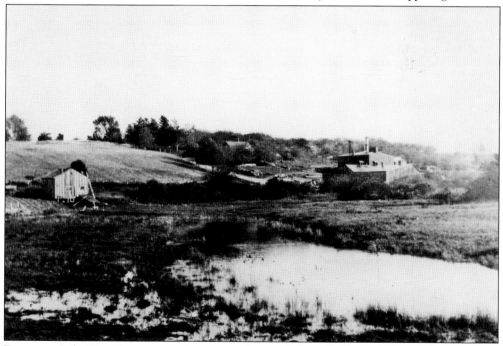

From near Lake Ontario, one can obtain a good view of the mill, Place's Hill, and the open field, as well as Ephraim Carnrite's carpenter shop on the left. Carnrite, who died in 1900, is said to have named California Road.

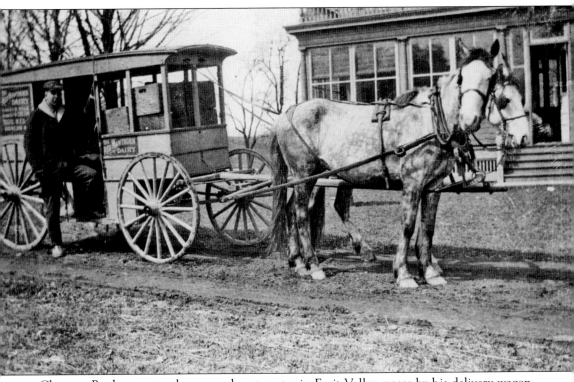

Clarence Bradway, a storekeeper and postmaster in Fruit Valley, poses by his delivery wagon. Residents would eagerly await his arrival.

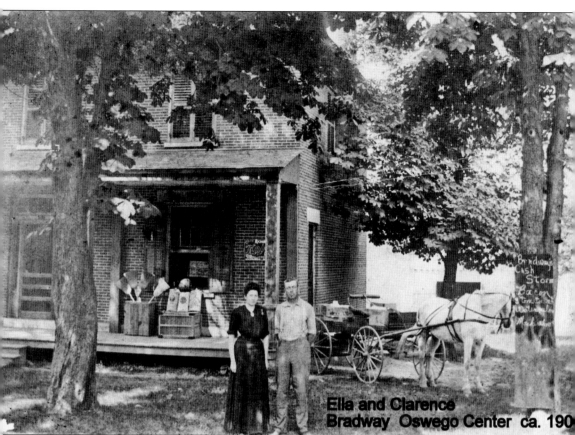

Ella and Clarence
Bradway Oswego Center ca. 190

The Bradways first had a store in Oswego Center before moving to Fruit Valley. They are pictured here around 1909. The brick store, now a private residence, was owned and operated by Milburn and Emma Cooper after the Bradways left. Note the brooms on the store porch.

C.A. Fisk's store, pictured here, stood at the intersection of County Routes 20 and 7 in Oswego Center. The store later became Thompson's Print Shop. The Thompson house is right behind the store and the trees. Note the road is unpaved in this c. 1900 image.

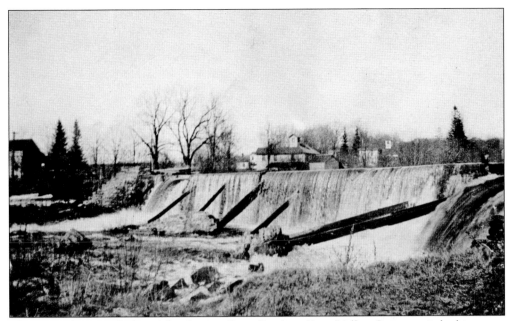

This 1916 photograph shows the dam on Rice Creek in Fruit Valley. Someone is looking over toward Route 104, or the Hannibal Road, as it was also called. This dam provided the power for Case's Grain and Feed Mill.

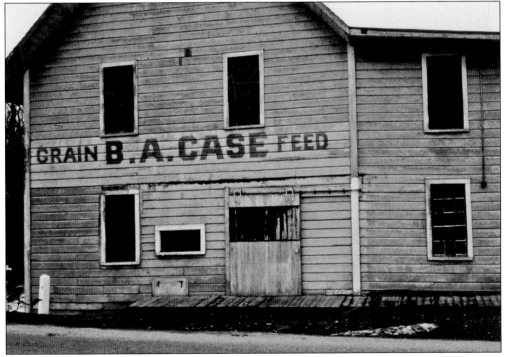

Case's Grain and Feed Mill, located on Route 104 in Fruit Valley, was owned and operated by Bertress Case. It was built by a Dr. Milne in 1888, who was killed soon after its completion. It was then sold to Jane Brownell. Bert Case, who worked for the Brownells, bought the place in the early 1900s. His son Bertress purchased it from his father in 1924 and operated it until 1957.

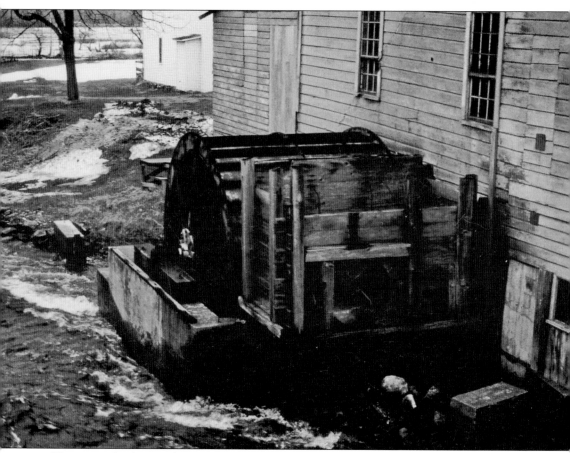

The water wheel is seen here on Rice Creek. It was sad for the community to see this well-known building taken from Fruit Valley's landscape.

Cheese production in the late 19th and early 20th centuries was prominent throughout Central New York as well as the whole state. This is a view of the California Road Cheese Factory in Southwest Oswego around 1900. The photograph was taken by Lyman Place, and the man is unidentified. Around 1911, Judson Simmons owned and operated the business. At left center is Philo Wheeler's house.

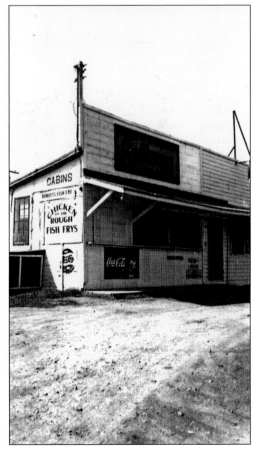

Galloways in Southwest Oswego, situated at the corner of Route 104 and California Road, was a place for good food and refreshment. The establishment was started by a Mr. Mulcahey; he built tourist cabins in the back. At the end of the season, Joe and Mrs. Galloway invited the schoolchildren from District 12 across the road for free hamburgers, hot dogs, fish, and ice cream. Note the advertising for "Chicken in the Rough" on the side of the stand. After the Galloways retired, the Clark family operated it.

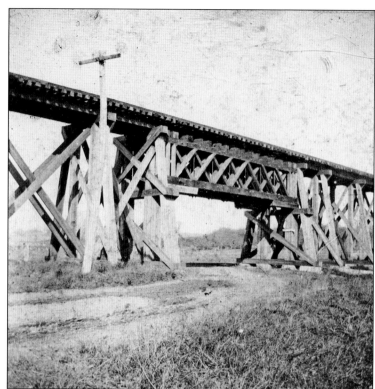

In 1868, the Lake Ontario Shore Railroad began in Oswego, then stretched into Hannibal, and on to Lewiston, New York. In 1873, a station was placed at Furniss (now Furniss Station) in Oswego. Fred Sabin was stationmaster for more than 50 years. This c. 1900 image is of the trestle on the Rathburn Road.

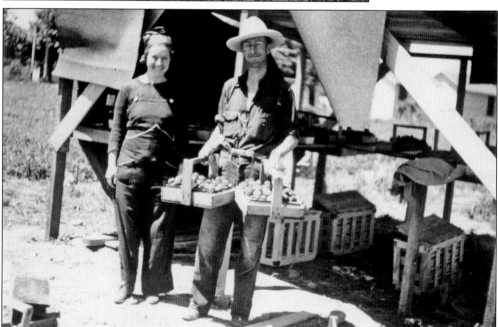

From the 1920s to the 1940s, the Oswego strawberry was well known on the New York City market. Many of those berries were grown in Oswego on the farms of Eddie Doyle, Spencer Brownell and Tony D'Ambra, and Wayne Gleason. Wayne and Shirley Gleason are pictured here with some of their prize berries in 1939.

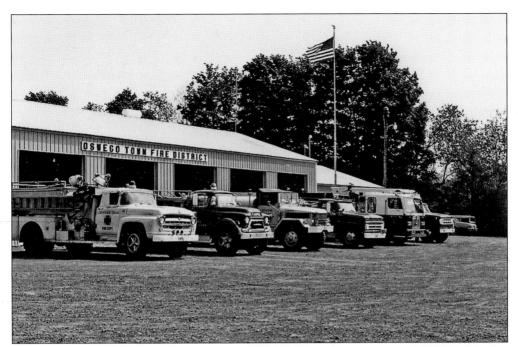

The Oswego Town Volunteer Fire Department was founded in the mid-1980s. The fire station, shown here with its equipment in the early years, is located on County Route 20, halfway between Southwest Oswego and Oswego Center. The department serves over 8,000 residents, including many SUNY Oswego students in Oswego Town. Over half of the college is located in Oswego. The town's courthouse is also in the building.

Columbian dolls were manufactured in the Town of Oswego from 1893 until 1917. The cloth dolls with hand-painted faces were made in the home of Emma E. Adams and Marietta Adams Ruttan on County Route 20. They received their name from the World's Columbian Exposition of 1893, where they were exhibited. Today, they are considered a very precious collectible. Adams, who died in 1900, is pictured here.

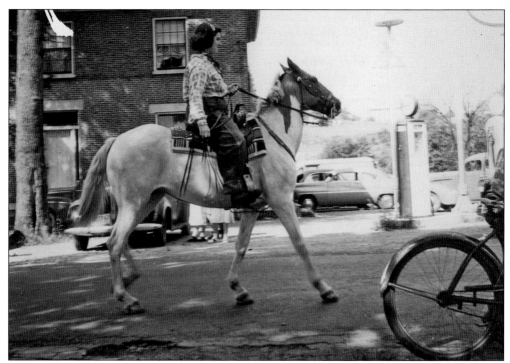

Oswego Center Old Home Days, sponsored by the Oswego Center United Methodist Church for many years, was a much-anticipated event. Contests, games, and food brought the people of Oswego Town together for fellowship and fun. In these c. 1950 images, Marjorie Westcott rides past Cooper's Store above; below, some local bathing beauties wish they were on a Florida beach.

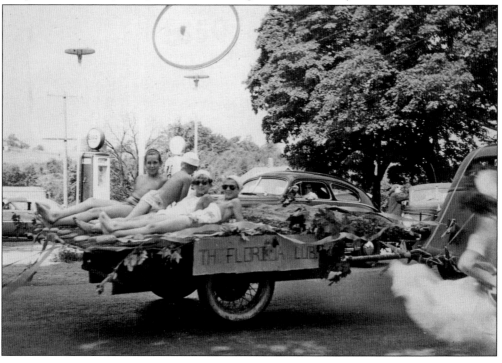

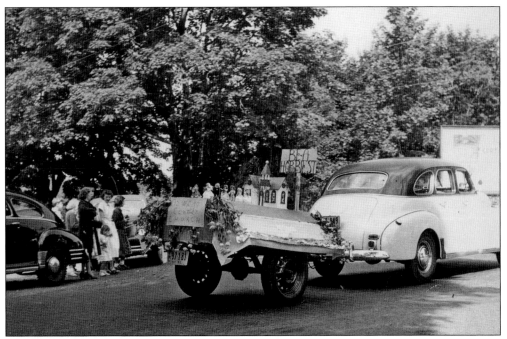

A church float passes by. Note the automobiles and fashion of the spectators. The trees, bordering the Johnson Road, no longer stand.

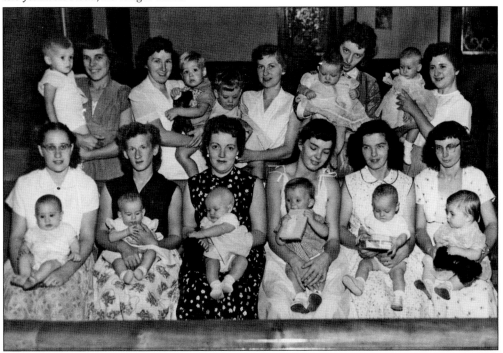

A much anticipated contest of Old Home Days was the baby show. Here in 1955 are the mothers and the prized contestants. From left to right are (first row) Carolyn Steele, Dorothy Sharkey, Betty Baker, ? Drake, ? Gibson, and Stella James; (second row) Evelyn Oleyourryk, Ella Cooper, Rebecca Trenca, Pearl Ellingwood, and Barbara Feyk. The winner is unknown.

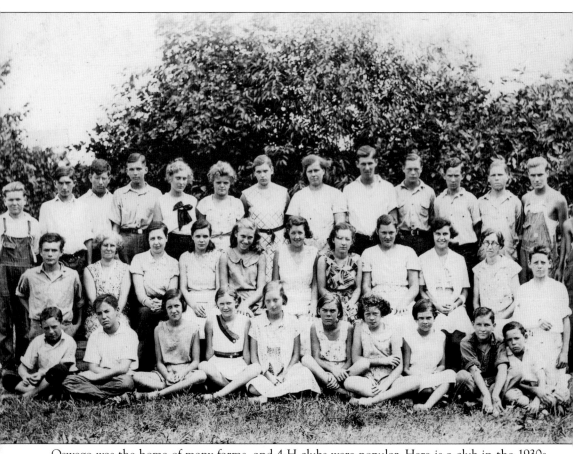

Oswego was the home of many farms, and 4-H clubs were popular. Here is a club in the 1930s meeting on what is now the West Lake Road. From left to right are (first row) Robert Dowie, Jack Hallinan, Anna McCracken, Charlotte Morrison, Ethel Adams, Thelma Platt, Eunice McCracken, Gladys Groat, Henry Weisen, and Richard Simmons; (second row) James Glerum, camp mother Celia Simmons, Lousie Bradway, Anna Glerum, Julia Place, Jane McCracken, Betty Dickinson, Mildred Place, Marian McMillan, chaperone Reta Ireland, and Norman Simmons; (third row) Charles Groat, Robert Wheeler, George Weisen, Clare Groat, unidentified, Catherine Barker, Arlene Place, camp director Lilly Place, Mason Place, Raymond Ireland, Harold Matthews, Bruce Ireland, Lyle Place, and Manford Place.

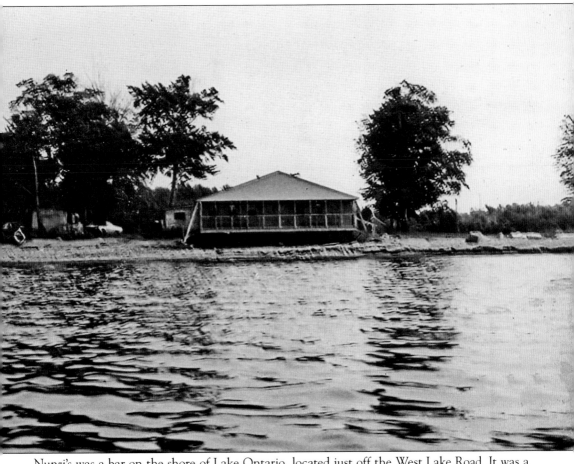

Nunzi's was a bar on the shore of Lake Ontario, located just off the West Lake Road. It was a favorite meeting place for locals as well as college students. Nunzi Salvadore and his place were beloved and well known throughout the town. This 1970 photograph was taken by Mary Ann Pritchard from a boat.

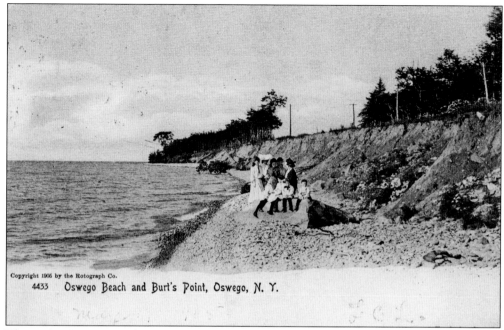

4433 Oswego Beach and Burt's Point, Oswego, N. Y.

This early 1900s postcard shows Oswego Beach and Burt's Point on the shore of Lake Ontario. The road with a trolley track above the beach is George Washington Boulevard.

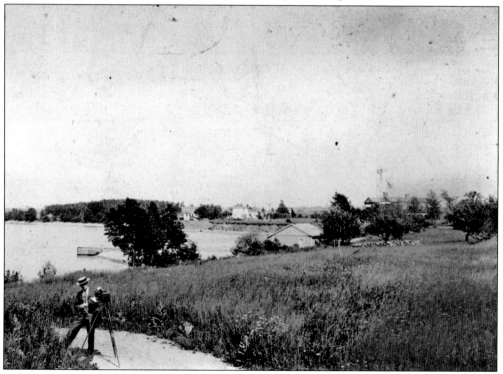

This is a c. 1900 image of Burt's Point. Note the photographer setting up to snap some shots. To the right is the roof of Wenonah Lodge. Built for lodging and dining, its life was not long, having burned down twice.

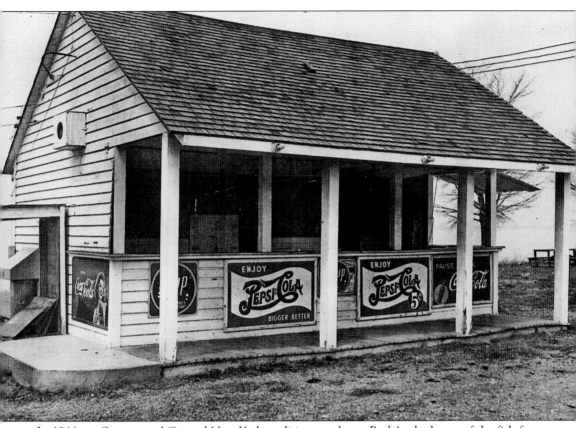

In 1946, an Oswego and Central New York tradition was born: Rudy's, the home of the fish fry and Texas Hots. The menu has enlarged with all kinds of seafood and burgers. This is the original stand located on Washington Boulevard. The amusement park was originally across from Rudy's. Note Lake Ontario and the picnic table to the right. Pepsi was only 5¢ a bottle. (Courtesy of Carol Livesey.)

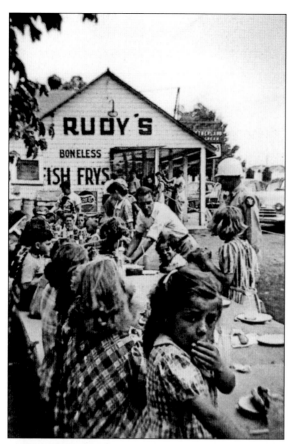

This early 1950s photograph shows residents of the orphan asylum in Oswego as Rudy's invited guests. Rudy's has always been a vital part of community life, ready to help make it stronger in every way. Note the uniformed security guard and the little girl enjoying her hot dog. (Courtesy of Carol Livesey.)

This 1900 photograph shows the Oswego Center Bicycle Club ready for an outing. Unfortunately, the riders are unidentified except for Marietta Adams, fourth from right. The club enjoyed leisure time in the early part of the 20th century.

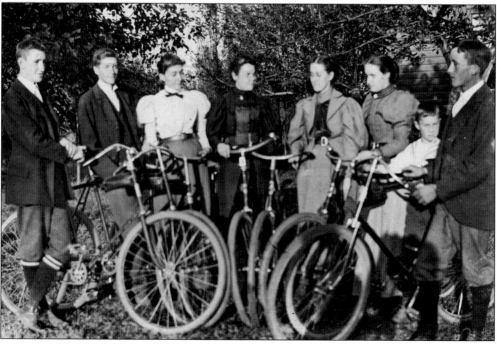

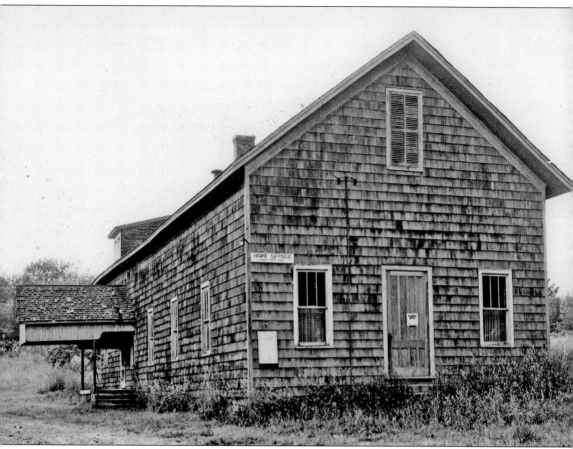

The Grange movement was prominent and strong in Upstate New York, especially in the Town of Oswego. Oak Grange was located in Oswego Center, and Hope Grange No. 115 was in Southwest Oswego. Hope Grange was established in 1874, organized by James Lee, a Medal of Honor recipient for his service in the Civil War. He took part in the Battle of Cherbourg between the *Kearsarge* and the *Alabama*. The Hope Grange building was erected in 1884. Hope Grange had its largest membership in 1905 with 326 members. It was the gathering place for many town residents, especially for its dances.

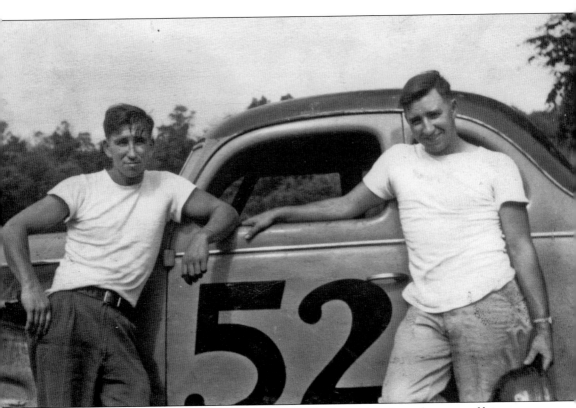

Years later, in the 1950s, brothers, Lloyd and Bob Sharkey enjoyed another type of leisure: race cars. Here, Lloyd (left) and Bob pose with their car. The famous Oswego Speedway is located just a few miles away in the city of Oswego.

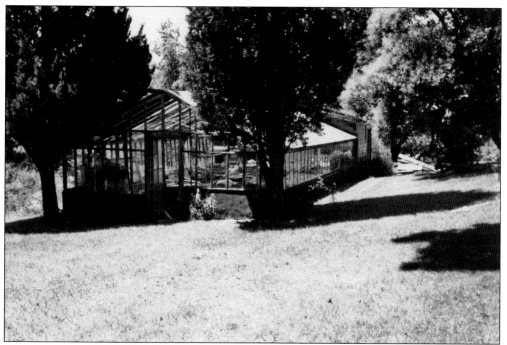

Anthony Czerow spent much of his leisure time in his greenhouse, pictured here. It was located on the Rathburn Road, where his descendants still live today. Anthony's son Tom and grandson Paul have grown Christmas trees in recent years.

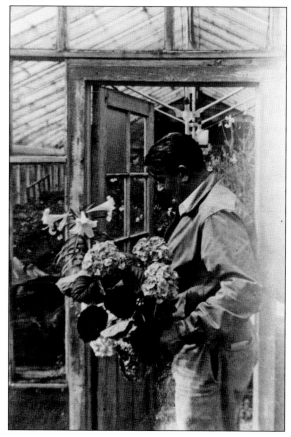

Anthony examines some of his Easter flowers. During the Memorial Day season, he raised many geraniums for decorating graves.

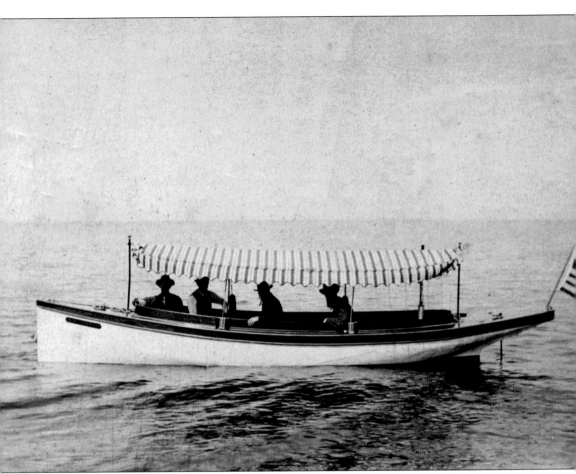

Fred and Ben Place, residents of Southwest Oswego, built a boat, and Lyman Place took a picture of its launching around 1900. Enjoying a leisurely trip on Lake Ontario are, from left to right, Fred, Ben, and Harley Randall, and Lorenzo Hinman.

Three

FACES OF THE PAST

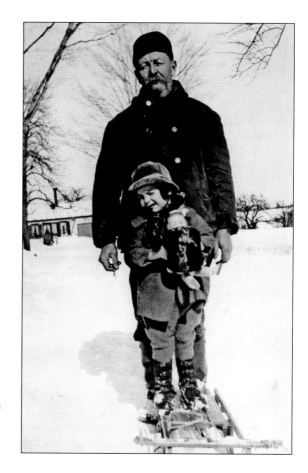

A familiar face for everyone in town was that of printer, husband, and father Nelson G. Thompson, the longest serving town clerk. Here, at his home in Oswego Center in the early 1920s, he is pictured with his daughter Nancy, with her doll and her sled.

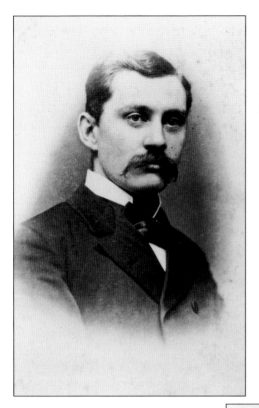

In the early 1880s, a young David Hall McConnell left his father's farm on what is now the West Lake Road to make his way in the business world. McConnell was the founder of Avon Products Inc., earlier known as California Perfume Company. This is an early image of McConnell from around 1886, the year of Avon's founding.

David Hall McConnell's younger brother George later left the farm and moved to California, where he managed the western branch of Avon. George McConnell is shown in his San Francisco office about 1890. He was a fine woodworker, and some of his pieces are still in the old farmhouse on West Lake Road.

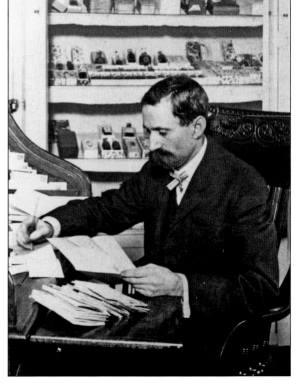

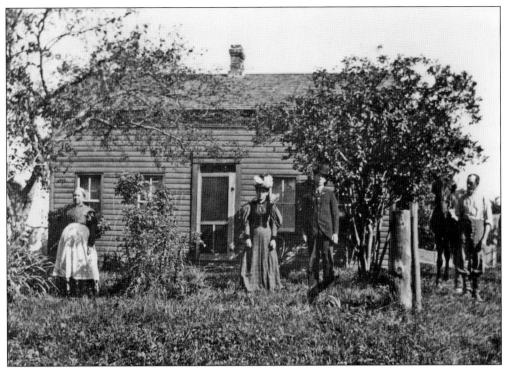

The Austin family on West Lake Road is dressed in their Sunday best for this photograph taken by their neighbor Lyman Place in 1898. From left to right are Mrs. Austin, Emma, Will, and Mr. Austin. Even the horse is included in the family portrait.

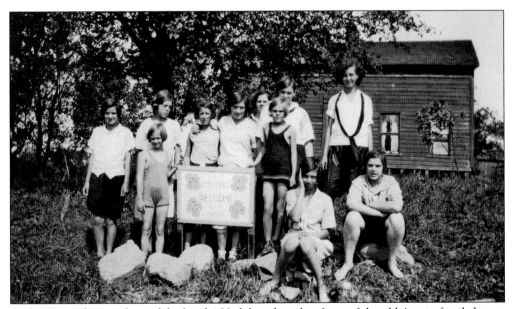

In the 1930s, the members of the local 4-H club gathered in front of the old Austin family home. The family had moved, and the house was a meeting place for the club. Arlene Groat stands on the right holding the club banner.

James and Isabella Hall McConnell emigrated from County Cavan, Ireland, around 1856. They settled on what is presently the Sabin Road near Southwest Oswego and, by 1869, moved to the West Lake Road. They were the parents of six children; one of whom was David Hall McConnell, founder of Avon. James was a farmer, and his farm was situated on the high banks overlooking Lake Ontario, on a place called Lewis's Bluff. The bluff was named after Simeon Lewis, one of the first settlers in the Town of Oswego. The McConnells settled in the area because it reminded them of their home in County Cavan.

This image of the McConnell home on West Lake Road was taken in 1898. The house was originally owned by Dan Timerson. The front of the house remains the same today. Standing proudly in front are, from left to right, James McConnell, his granddaughter Vernice, his son Joseph, his granddaughter Luella, and his daughter-in-law Nettie.

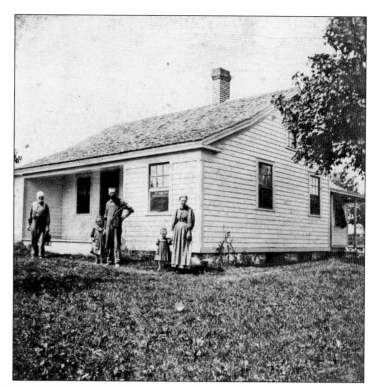

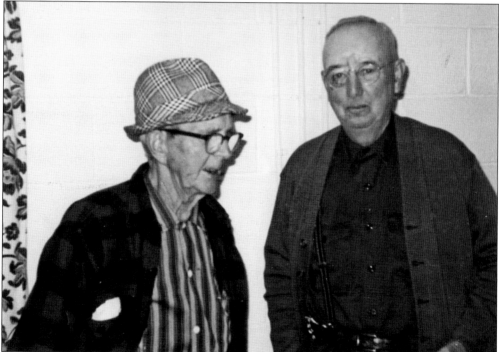

Neighbors Dewitt Groat (left) and Bill Sabin talk about their farms after a roast beef dinner at the Southwest Oswego United Methodist Church in the 1960s. Groat was a dairy and fruit farmer on California Road, and Sabin had a small dairy and muck land where he grew onions.

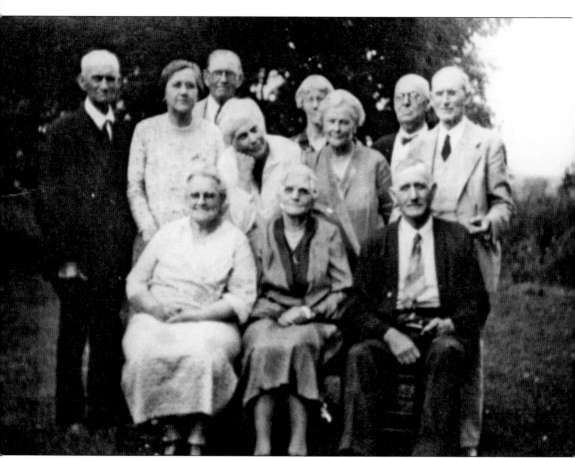

The children of James and Isabella McConnell meet for their last reunion in the late 1920s at the family farm. They are, from left to right, (seated, first row) Hattie McConnell McMillen, Margaret McConnell Groat, and Rob McMillan; (second row) Joe McConnell, Liesbeth McConnell, David McConnell, Lou McConnell, Emma McConnell, Nettie McConnell, Will McConnell, and George McConnell.

Chester and Sarah Powers Randall of the West Lake Road are pictured here. Chester came from Rhode Island with his mother, Betsey. Betsey's husband, Richard, had died, and she decided to move west, settling on land by Lake Ontario where Chester farmed. The land is still owned by the family.

Margaret McConnell Groat is pictured with her son Charles in 1887. Groat was a dressmaker by trade and as a single mother, she raised three children: Charles, Isabel, and Dewitt. She was active in the Southwest Oswego United Methodist Church and First Methodist in Oswego and the local District No. 1 school activities.

Dewitt and Jennie Vincent Groat pose for their portrait, probably at the time of their wedding. Dewitt was a prominent fruit farmer in Southwest Oswego. His crops of pears, apples, and sour and sweet cherries were the envy of the neighborhood. His farm, though not producing, remains in the family. It is located on California Road.

Margaret Groat DeMass poses in her fashionable swimsuit in the late 1920s. She was typical of women at that time; she remained in her hometown and was active in church and school district life.

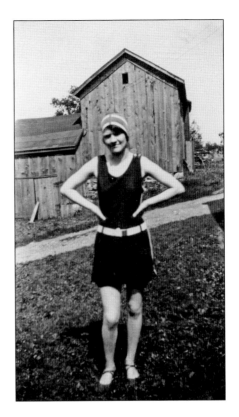

John and Tressa King of California Road pose in front of their home. John's parents came to town from County Monaghan, Ireland, in the 1860s. He was a prosperous fruit farmer, especially in pears. Tressa was a schoolteacher in the area. She was the first woman to serve on an Oswego County jury in the late 1920s.

The McConnell girls—Vernice (left) and Luella—were daughters of Joe and Nettie (Wiltsie) McConnell. The McConnell family was typical of the farm families throughout the town. Vernice was a teacher and a local farmer.

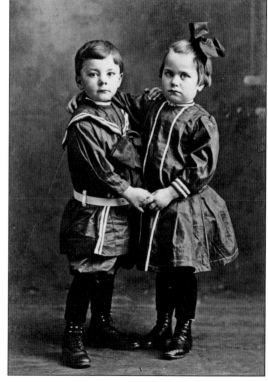

The McConnell twins—Ernest and Gladys—were also children of Joe and Nettie McConnell. The twins were born in 1906, and Gladys died a few years later. Ernest, nicknamed "Mac," stayed on the West Lake Road farm and ran a dairy farm. He spent his final years as a member of the Town of Oswego Highway Department.

It was a proud day when Florence Sabin turned 10 and had a formal portrait taken in 1915. The Sabin family was among the first settlers in town. One branch settled in Oswego Center and another in Southwest Oswego. Florence married and moved away but returned every year to visit family and neighbors.

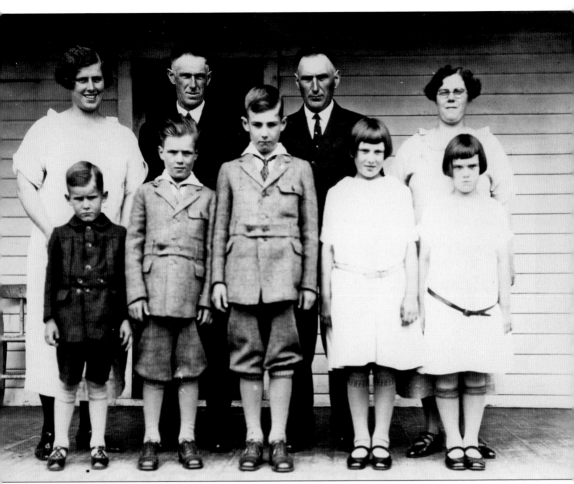

The Place family of Southwest Oswego gathered on the front porch for this family picture around 1930. Brothers Fred and Ben Place owned and operated a local cider and vinegar mill. From left to right are (first row) Manford, Lyle, Mason, Mildred, and Arlene; (second row) Lilly, Benjamin A., Fred, and Dorothy.

Philo Wheeler came to Oswego Town from Jefferson County to the north. Wheeler, a wagon maker and blacksmith by trade, settled on California Road. He was active in the local Democratic party and the Masonic lodge. He also served for many years as a railroad commissioner.

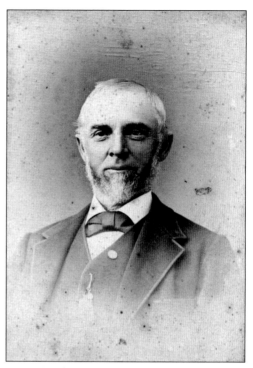

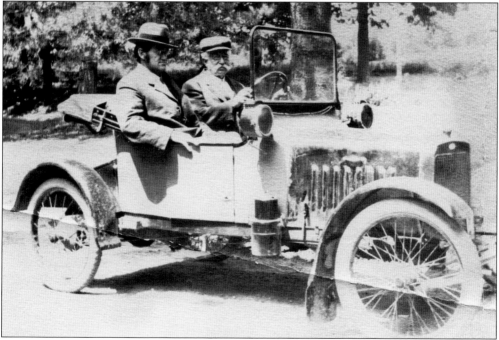

A well-known face in town was that of Dr. Edgar J. Marsh of Southwest Oswego. He first started practicing medicine in Hastings, New York, and came to the Town of Oswego in 1873 upon the death of Dr. Simeon G. Place. In the great flu epidemic of 1918, out of 400 patients, he lost one. This photograph shows the doctor on the right with his son Dr. Milton Marsh of Hannibal as they ride in a Saxon auto.

Dr. Simeon G. Place came from Rhode Island and was one of the first physicians in Oswego Town. He settled in Southwest Oswego. His home was at the intersection of Routes 104 and 104A. This image of Dr. Place was taken April 2, 1865, near the end of the Civil War. He was a surgeon in the 147th New York Volunteer Infantry. His home later served as the Southwest Oswego Post Office.

Benjamin B. Place of the West Lake Road, a dairy and fruit farmer, was among the vast number of descendants of Samuel Place, an early settler. Place was a justice of the peace, Oswego town historian, and an active member of the Southwest Oswego United Methodist Church. His knowledge of local history and art of storytelling made him a well-known resident of the town.

Mr. and Mrs. Dennler, pictured here, were a well-established part of the Oswego Center community. Their home was on County Route 20, situated just past the hamlet and before the ascent of Cornish Hill. Their daughter Florence became a teacher and moved from the area. On retirement, she returned to the Town of Oswego and served as town historian. Marguerite Hanson (left) is pictured here with the Dennlers.

Tracy (left) and Reuel Todd are shown here at the Northrop Studio in Oswego on April 21, 1902. Reuel was six years old, and Tracy was four. The Todd family was a vital part of the town and especially Oswego Center, where they resided. Reuel and Tracy were associated with their father's vinegar works on the Johnson Road. The Todd family remains active in the greater Oswego County community today.

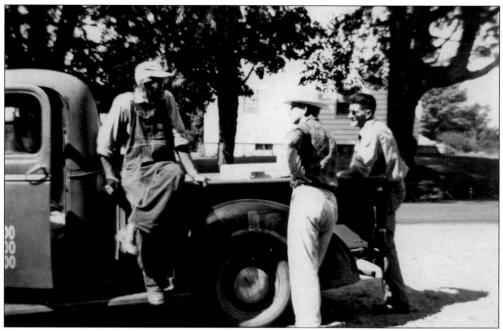

Three longtime neighbors meet up at Cooper's Store at the four corners in Oswego Center in the 1960s. From left to right are supervisor Fred Haynes, Milburn Cooper, and Lyle Hutchinson. Haynes's collie is in the truck; she always traveled with him. Haynes was the longest serving supervisor, from 1942 to 1959.

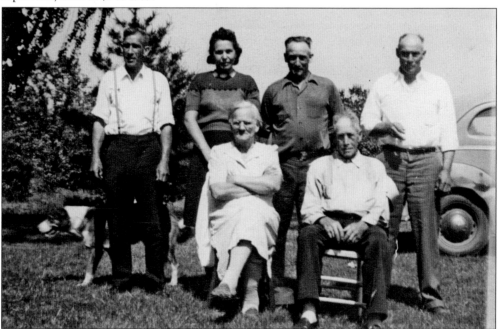

The Johnson family was prominent in Oswego. Johnson Road (County Route 7) is named for them. Leroy Johnson's family is gathered for a portrait. From left to right are (first row) Fannie and Leroy Johnson; (second row) George, Mildred Horton, Cecil, and Orville. Orville lived on Thompson Road near the site of Griffins Cider Mill.

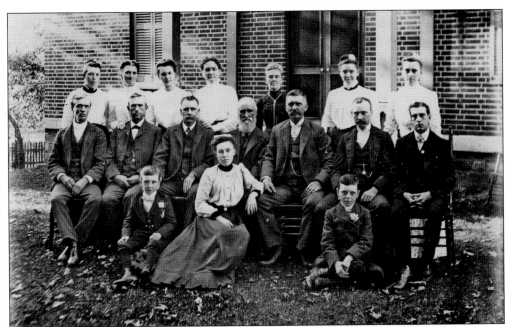

In 1903, the descendants of Vincent Sabin met at the old homestead on California Road in Southwest Oswego. The house is now the home of Roger and Mary Ann Pritchard. From left to right are (first row) William Vinton Sabin, Celia May (Sabin) Phillips, and Charles Albert Sabin II; (second row) Lewis Austin McBride, Arthur Gilman Chase, Charles B. Chase, Ansel "Uncle Bennett" Havens, Albert Alpheus Sabin, Charles Albert "Allie" Sabin, and Frank S. Rhoades; (third row) Cora Maude (Sabin) McBride, Harriett Jane (Gill) Chase, Myra Catherine (Chase) Jones, Mary "Mate" (Hatfield) Chase, Mary Louisa Jane (Chase) Sabin, Jennie Edith (Pritchard) Sabin, and Myra Elizabeth "Libbie" (Sabin) Rhoades.

Frank A. Place, a former town supervisor during the last few years of the 19th century, is pictured enjoying retirement in Florida. Place lived on the corner of Sabin and West Lake Road and was a prosperous fruit farmer. His crops included peaches, pears, apples, and cherries.

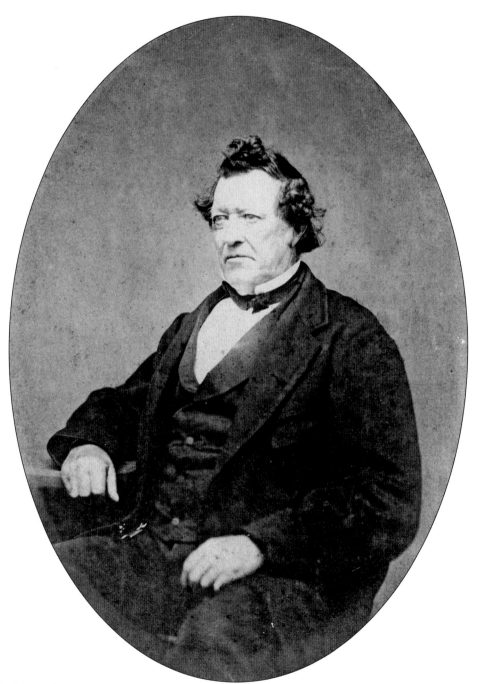

"Uncle" Joe McCoy, as he was affectionately known in town, was one of the first settlers. He resided in Southwest Oswego. He and his wife, Nancy, sold the property for the Baptist church in the community for $24 in 1852. The lot was at the summit of the hill on the corner of Route 104 and County Route 20. Joseph and Nancy's daughter Sarah married into the Maxon Lewis family, another prominent family in Southwest Oswego. Uncle Joe later left the area and moved west. His relative John McCoy owned the famous Raulston Inn in Southwest Oswego. Pres. Martin Van Buren, who had close ties in Oswego, was an overnight guest.

"Gramma" Sarah Bishop is seated in her home in Southwest Oswego at the corner of Route 104 and California Road. The house still stands today. Gramma Sarah was the sister-in-law of Rev. Artemas Bishop of the Bunker Hill Road Bishops. Reverend Bishop was one of the first missionaries to Hawaii and one of the translators of the Hawaiian Bible.

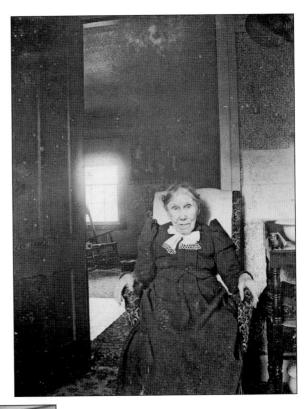

Celia (Irwin) Simmons, born in 1886, lived to be one of Oswego's oldest residents, dying at 106. Her grandfather Nathaniel Laird lived to be the oldest resident of the town. He voted at the age of 109 and died at 111. No one in town has surpassed that achievement. Both were residents of Southwest Oswego. Celia married Judson Simmons and was active in both the Baptist and Methodist churches.

Charles and Sarah Barstow were owners and operators of Barstow's Store in Southwest Oswego in the early 1900s. Charles's father, Ormond, operated the store before him. The Barstows were active in the Southwest Oswego United Methodist Church and throughout the community.

Frank Eaton of Southwest Oswego is pictured here with his horse in front of his farm on Route 104A. This picture was taken for the slide presentation at the Southwest Oswego Baptist Church's centennial in 1939. Eaton and his wife, Ada, were active members of the congregation for many years. They were both well loved and respected in the community.

Some neighborhood kids admire the new baby in town, Margaret Groat of Southwest Oswego, in 1913. Her new friends are Emma Place, Ernest McConnell, and Marian Place. Those days in Oswego were ones of neighboring and nurturing.

Maggie Pritchard emigrated from County Monaghan, Ireland. She lived with her sister, Lizzie, and Lizzie's husband, David Hall, on the Hannibal Road. This photograph was taken near the end of her life at her home. She died in December 1935 at the age of 90.

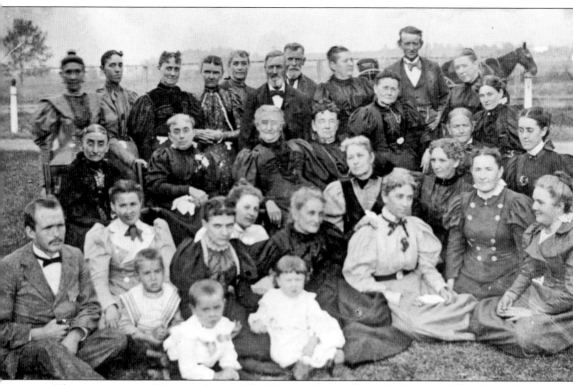

This is a portrait of the members of the Oswego Center United Methodist Church in the late 1890s. The adults are, from left to right, (first row) Reverend Holmes, Mrs. T.G. Thompson, unidentified, Mrs. Edith Holmes, Mrs. George Baker, Anna Graham, Mrs. Lester Wright, Mary Leadley, Carrie Powell, and unidentified; (second row) Mrs. George Cornish, Mary Cornish, Mrs. George Newell, Martha Todd, Aurora Coates, Hattie Brewster, and Marietta Adams Ruttan; (third row) Mary Jane Taylor (who donated the property for the church), Mrs. Dunlap, three unidentified women, Horace Todd, William Adams, Laura Leadley, unidentified, Asa Pease, and Mrs. James Griffin.

Four

HOUSES AND ROADS

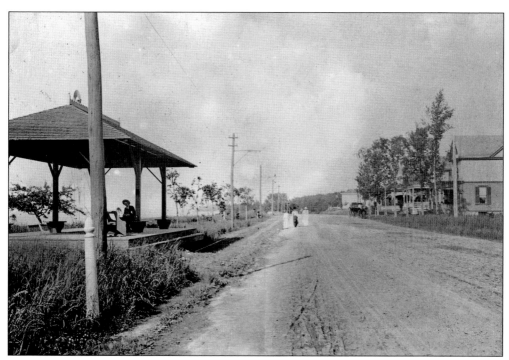

George Washington Boulevard is one of the most well-known roads in the Town of Oswego. This c. 1900 image shows the boulevard and looks east toward Oswego. Lake Ontario is on the left with the trolley station. The White Horse Hotel and amusement park was just up the boulevard to the right. The trolley came out from the city and made a loop to return; thus, the area was named the Loop.

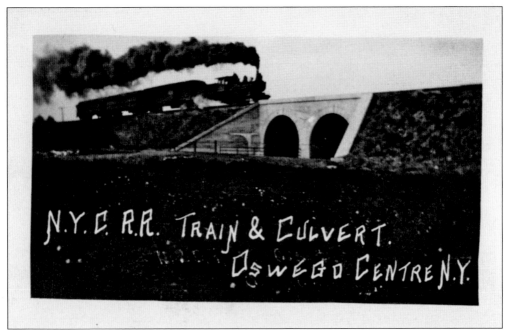

This vintage postcard shows the New York Central Railroad train and the culvert on the Rathburn Road in Oswego Center. Note the spelling of "Centre." This old spelling dates to 1867, when the name was changed from Fitch's Corners.

Maple Avenue is seen here around 1900. This is now County Route 20 from Oswego Center. Sadly, these beautiful maple trees no longer line the roadway, which was still dirt at the time. The two children are unidentified.

This postcard shows the trolley coming from Oswego via Washington Boulevard to the Loop. Lake Ontario is on the left. This was a favorite spot for many Oswegonians, both from the city and the town. It is still popular today, as people frequent Rudy's.

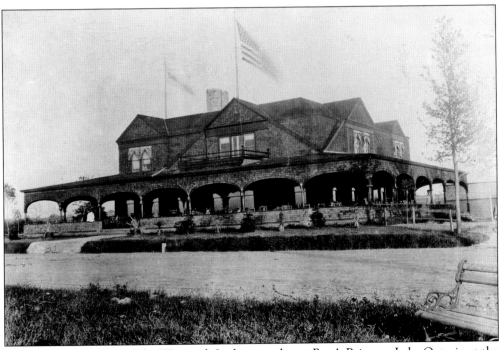

Café Ontario was part of the Wenonah Lodge complex at Burt's Point on Lake Ontario at the end of the boulevard. It was a beautiful place to relax, enjoy the lake breezes, and eat and drink. Unfortunately, it was lost to a fire.

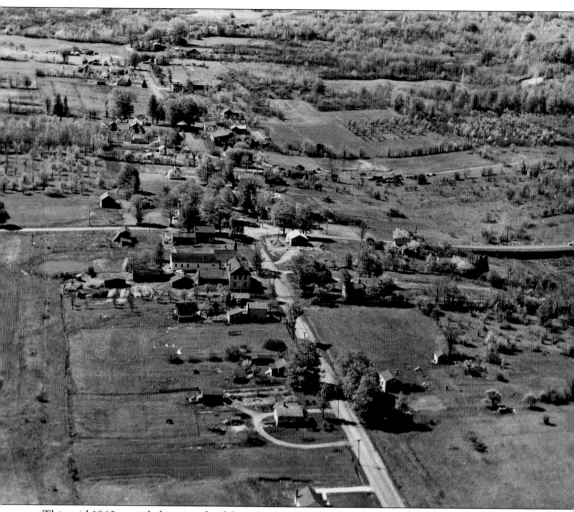

This mid-1960s aerial photograph of Oswego Center shows the four corners of the County Routes 7 and 20 intersection. County Route 20 runs from east to west, and County Route 7, also known as Johnson Road, runs north to south. The Oswego Center United Methodist Church and town hall are at center left. Dasan's blacksmith shop was just to the north of the hall, and across from the hall is the District No. 10 two-room schoolhouse. Note the beautiful farmland and orchards once so prevalent in Oswego.

The Adams-Ruttan house, pictured here, dates to at least 1823. The upright portion of the house was built in 1848. Today, the porch is gone. William Adams purchased the house in 1852. Etta Adams Ruttan and sister Emma made their famous Columbian dolls here.

The Jeffrey homestead was also known as the Fitch house. Henry Fitch settled here in 1833 and served as town clerk. Horace Fitch was Oswego Center's first postmaster in 1867. Henry Jeffrey purchased the house, and later, Lorena Jeffrey sold it to Jack Scozzari. Unfortunately, it burned in recent years.

A winter scene frames the Fisk-Thompson-Snygg house in 1919. It is located on the corner of County Routes 7 and 20. Charles Fisk operated a general store here by the house. That store later became Nelson Thompson's Print Shop. It is thought that the house dates to 1865. It was later sold to Dr. Donald Snygg, a professor at SUNY Oswego. Belle Thompson stands out front.

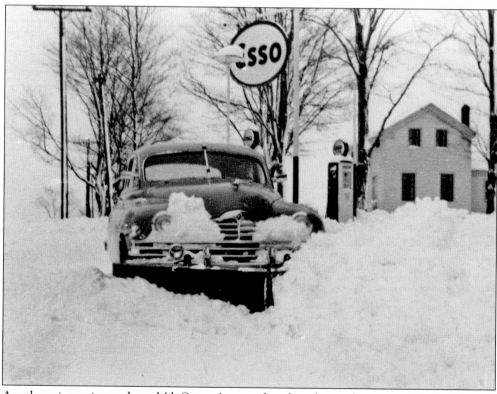

Another winter picture shows Mib Cooper's car with a plow, doing what many do in the Town of Oswego at certain times of the year. This image was captured in front of his store on the corner of County Routes 7 and 20. The Thompson-Snygg house is on the right.

From left to right, Jean Marie DuBois, Louise Cooper, and Jack DuBois run from Louise's father's store, which was located across from the town hall at that time (1937). The Jeffrey family's house is seen at center.

Lassie, John Morris's great dane, stands in the middle of Johnson Road across from the town hall. "Pat" Dasan's house and blacksmith shop are in the center. The cars are parked at the town hall.

July 1935 saw the paving of Maple Avenue, also known as County Route 20. This photograph was taken at the four corners. Thompson's Print Shop is on the left, and what is now Cooper's Store is to the right. Progress is in action.

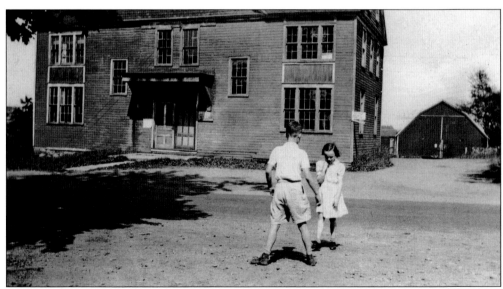

In 1937, Louise Cooper and Jack DuBois play a game on the Johnson Road with the town hall/ Grange Hall in the background. The town sheds of the highway department are to the right.

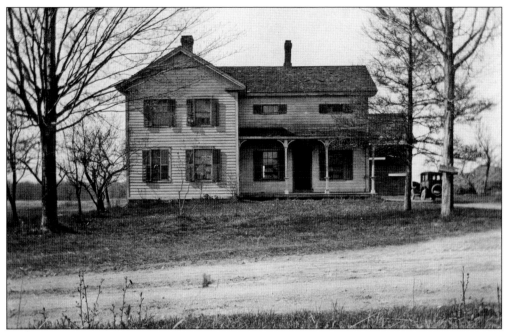

This picture of the Sam King house on California Road was taken in the early 1900s. Sam and Eliza (Hall) King lived here. The road is not paved. Sam, born in Ireland, was a prosperous farmer. His son George was killed on the farm. Sam was cutting the grass with a scythe around a stone wall and did not see his son, accidentally striking him.

One of Sam King's neighbors was Andrew Gallagher. He sits in front of his home, built in 1859 by his father, Patrick Gallagher. They were also immigrants from Ireland. Note the straw boater hat Andrew is wearing.

The McCracken farm on Route 104, located near the summit of Perry Hill, was a well-known farm in Oswego. This is an image of the farmhouse owned by Thomas and Mabel McCracken. Tom also worked with the Oswego County Sheriff's Department. Mabel, a teacher, was active as an Oswego County Republican committee chairwoman for years.

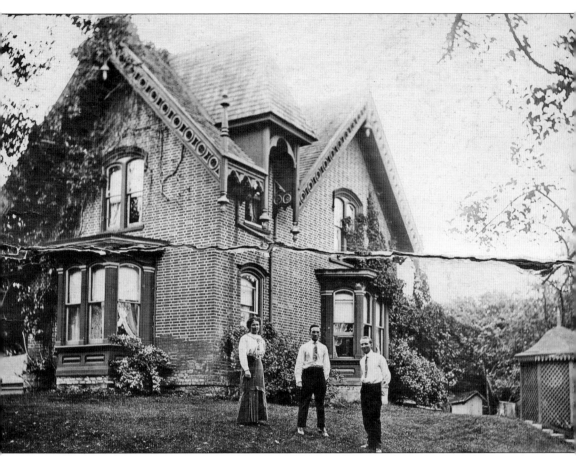

T.S. Brigham of Fruit Valley built this brick house known as the Dickinson house. Brigham also built the structure known in the past as Greenman's Gardens. The barn was built first and used as a workshop to make parts for the house. Members of the James and Catherine Dickinson family are pictured in the front yard.

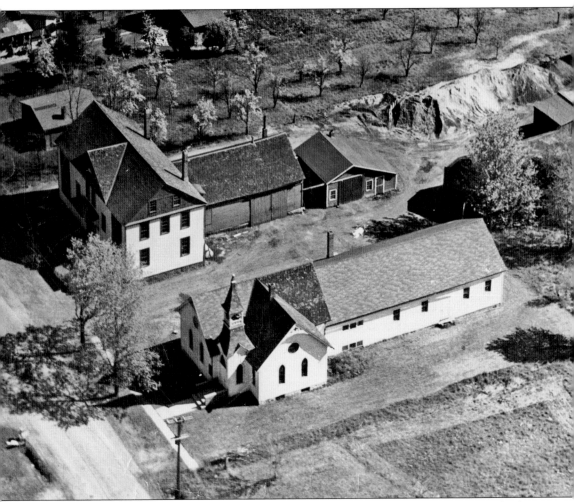

This 1950s aerial view of Oswego Center offers a good view of the Oswego Center United Methodist Church and the town hall. Johnson Road runs along the left. To the north is Dasan's blacksmith shop, and an orchard is seen at top. This is where the Oswego Town Park is today. The sand pile for the roads in winter is behind the town sheds.

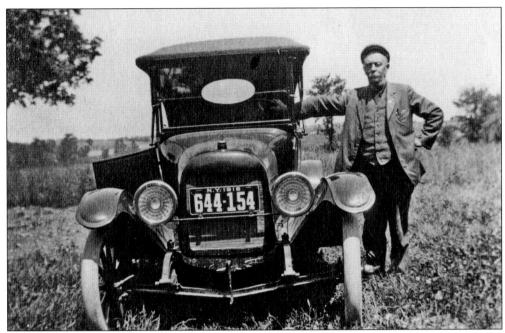

Nelson Thompson is proud of his automobile in this 1918 image. Thompson and his auto were a familiar site on Oswego roads. Note the hand crank in front of the car, which was used to start it.

Thompson's car took many trips up and down this road, Maple Avenue. This view looks east from Cornish Hill. Note the harvest shocks in the field at right and the orchards to the left. The Oswego Center united Methodist Church is on the horizon with the Jeffrey house in the center and the Bradway/Cooper store to the right. The Dennler home is in the front center amidst the orchard.

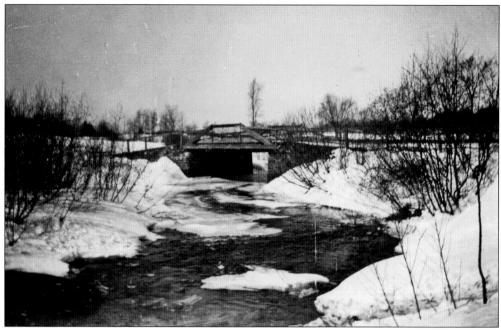

Lyman Place took this picture of Eight Mile Creek Bridge on California Road in 1898. Many skated on the nearby millpond, and Place's Hill, seen to the right of the bridge, was great for sledding (and still is). The creek flows out into Lake Ontario, beyond the bridge.

William and Jane Brownell are pictured at their home and mill in the late 1890s. The mill was built in 1888 by a Dr. Milne. The Brownells sold it to the Case family. Note that Route 104 is not paved, and also the dog and the bicycle leaning against the tree. Three Mile Creek runs to the west of the mill.

Five

REFORMS AND JUSTICE

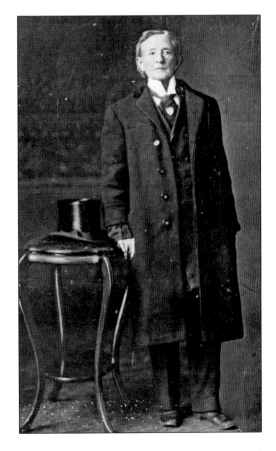

Dr. Mary Edwards Walker energetically
took up the banner for reform in education,
women's fashion, women's suffrage, women's
rights, and medicine. She spent the years
after the Civil War lecturing at home
and abroad in Great Britain. This picture
from her advertising flyer, stating her
credentials, shows her in her later years,
dressed in pants, frock coat, and top hat.

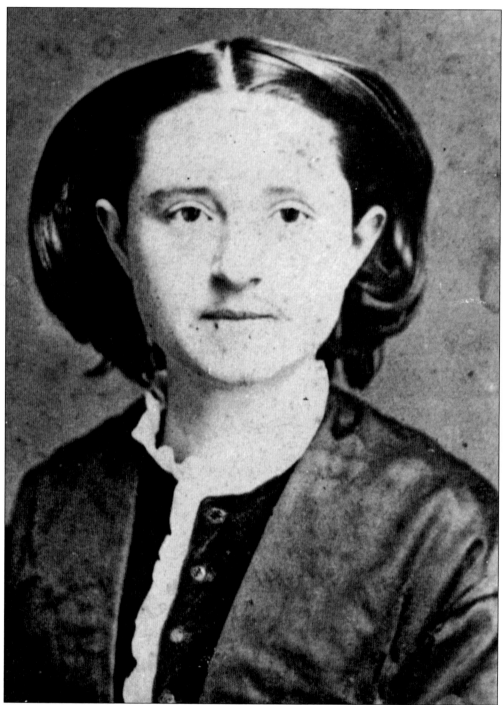

"Dr. Mary," as she was known even to her family, was born on Bunker Hill Road on November 26, 1832. This is the earliest known image of her. Her father, Alvah, a man ahead of his time in his thinking on social issues, encouraged her to forcefully advocate for reform in all dimensions. She taught in a school in the nearby hamlet of Minetto before she entered Syracuse Medical College, where she graduated in 1855.

Dr. Walker offered her medical services in the Civil War. She became a contract acting assistant surgeon and often treated civilians in enemy territory as well. This image of her was taken in Oswego in 1864. Dr. Walker spoke out against the vast number of amputations performed during the war, believing many were unnecessary.

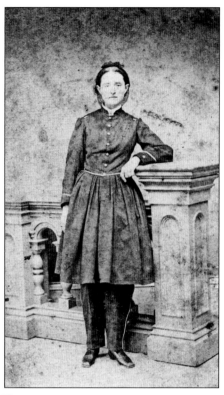

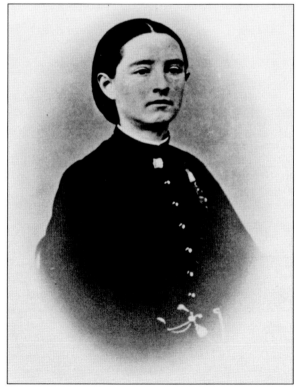

Dr. Walker is seen soon after the war wearing her surgeon's pin by her collar. She was at the First Battle of Bull Run and Fredericksburg. She was later taken prisoner and placed at Castle Thunder. Dr. Walker was the first female surgeon employed by the US Army.

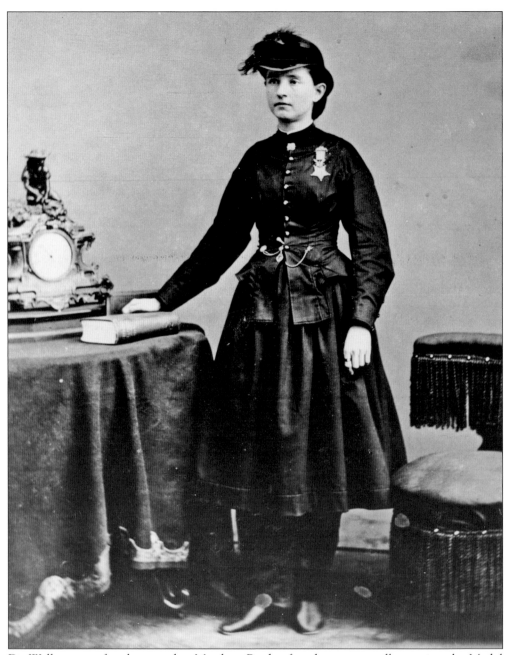

Dr. Walker poses for photographer Matthew Brady after the war, proudly wearing the Medal of Honor. Upon the recommendations of Generals William T. Sherman and George Thomas, Pres. Andrew Johnson awarded the Medal of Honor to her on November 11, 1865. She is the only woman to receive this honor. Note her skirt worn over pants. This was her mode of dress on the battlefield.

It is said that Dr. Walker was the most photographed woman in America in the last half of the 19th century. She was always ready for a photo op. This is a more formal pose in her later years.

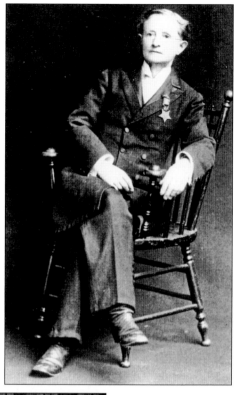

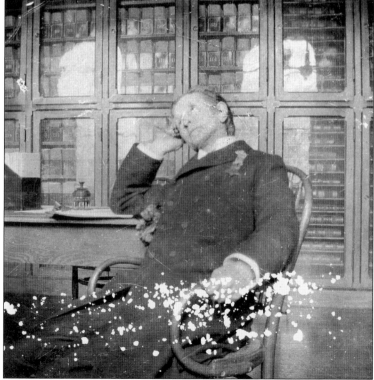

This image is thought to have been captured in Dr. Walker's home on Bunker Hill in Oswego. She is in deep thought and proudly wears her medal, which she wore daily.

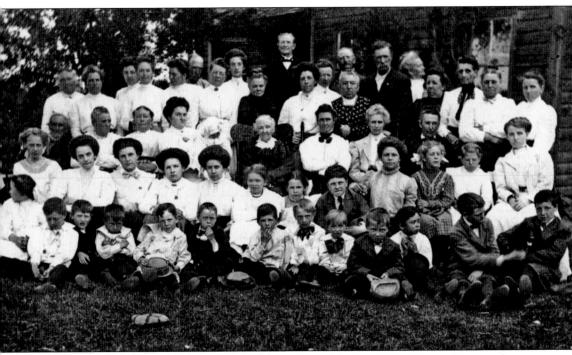

This postcard from the early 1900s shows the neighbors of Bunker Hill in Oswego Town gathering for a picnic. Dr. Walker stands proudly in the middle of the top row, wearing a dark jacket. She was liked by some and thought too aggressive and eccentric by others, but all seem to be congenial for this picture.

Dr. Walker is seen here probably during the war. Though accused of wearing men's clothes, she often displayed quite feminine fashion, as shown here. Note the skirt over the pants, with more of a fitted top. She discouraged women from wearing corsets, as she declared them unhealthy.

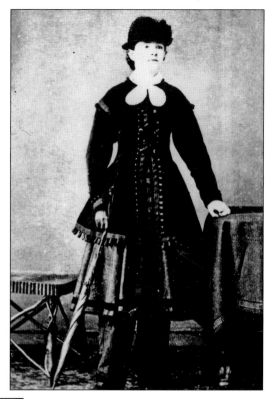

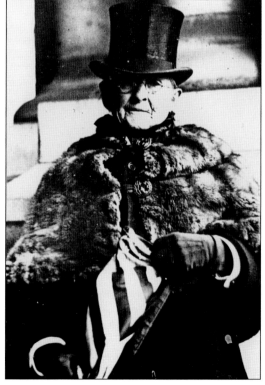

Dr. Walker stands in her later years wearing her fur cape. She often appeared at Congressional hearings at the US Capitol lobbying for her causes. She was especially vocal against the annexation of Hawaii. She later took a fall from the Capitol steps, which soon led to her death in February 21, 1919, at the age of 86.

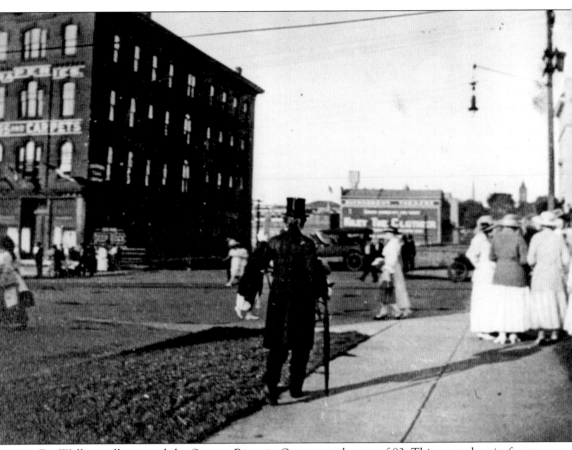

Dr. Walker walks toward the Oswego River in Oswego at the age of 83. This was taken in front of city hall. The spire of the Church of the Evangelist is seen in the upper right across the river. Note the fashion of the day displayed by the group of ladies on the corner.

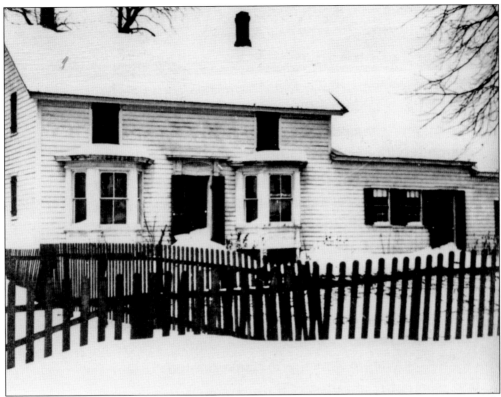

The Walker homestead on Bunker Hill is seen in this 1920 winter scene. The house unfortunately burned in 1923. The site was also that of one of the first schools in the area, established by Dr. Walker's father. That school building was just recently torn down.

In July 1999, the Oswego Town Board placed a historical marker at the site of Dr. Walker's birthplace and homestead on Bunker Hill. From left to right are county legislator Douglas Malone, supervisor Jack Tyrie, council member Victoria Mullen, Rosemary Nesbitt (dressed as Dr. Walker), town clerk Theresa Cooper, town historian Charles Groat, and council member Barbara Tierney.

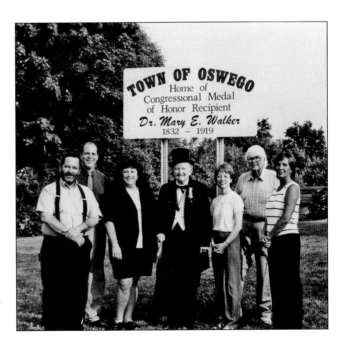

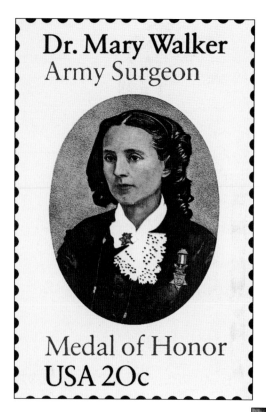

Dr. Mary Walker
Army Surgeon

Medal of Honor
USA 20c

In 1982, the US Postal Service issued a commemorative stamp honoring Dr. Mary Edwards Walker. The stamp was designed by Glenora Case Richards of New Canaan, Connecticut. Bernard Driscoll was postmaster in Oswego for the event.

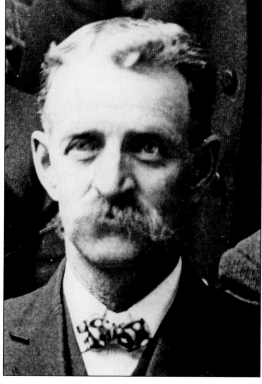

Byron Worden, supervisor of the Town of Oswego from 1903 to 1905, was Dr. Walker's nephew. He was her caregiver and executor of her affairs in her later years. Dr. Walker died peacefully at her neighbors' house, the Dwyer home, on Maple Avenue.

Dr. Walker is shown here at an exposition in Paris in 1867. She is draped in an American flag, but no medal is to be seen. Note her quite distinct autograph.

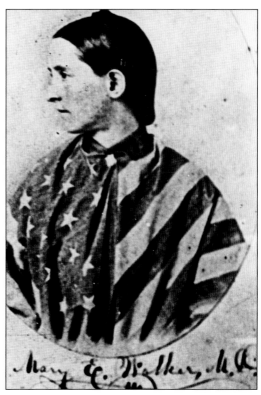

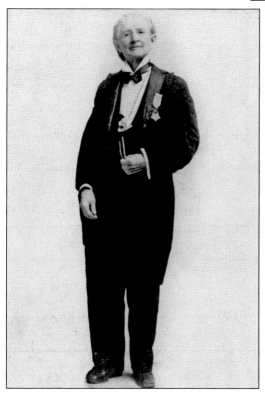

Dr. Walker used this characteristic pose for publicity in her later years. Again, her medal is prominently displayed on her waistcoat. She was small in stature but had large hands. Note the rose in her vest.

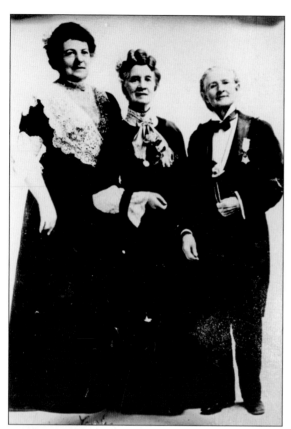

In about 1908, three pioneers of women's rights met in Oswego. This picture records that event. Dr. Walker is seen here with the Rev. Susana Harris and attorney Belva Lockwood. Lockwood ran for president in 1884 and 1888.

Dr. Walker rides with some of her suffrage friends. They are unidentified, and the location of the photograph is unknown. Dr. Walker broke with suffrage leaders Elizabeth Cady Stanton and Susan B. Anthony. She did not think it necessary to have a constitutional amendment for women to vote, since she felt women already had that right. Stanton and Anthony thought Walker was too aggressive in her approach.

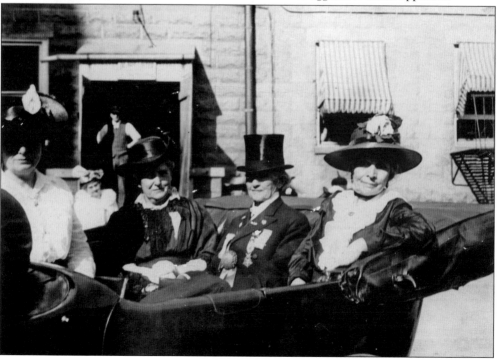

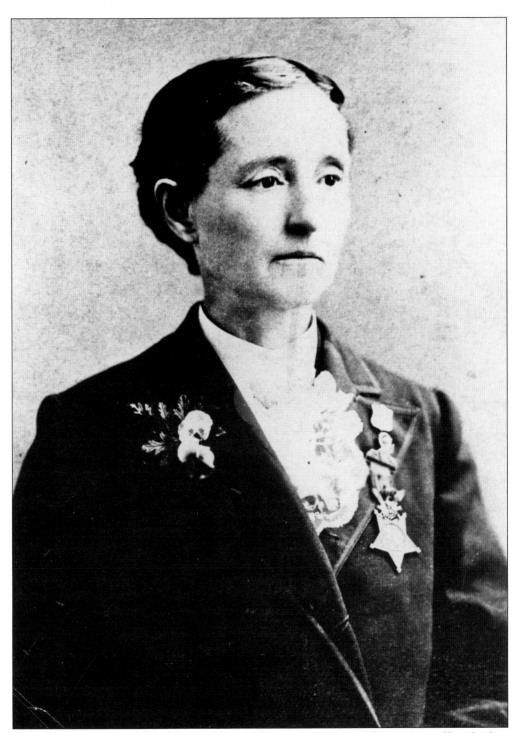

Dr. Walker is seen here with flowers, lace, and her medal. This popular portrait of her displays the medal well. Congress recalled her medal in 1917, as well as over 900 more. She would not and did not return it. After diligent work from grand niece Helen Wilson, and many legislators, Pres. Jimmy Carter restored it. It rests today at the Oswego County Historical Society.

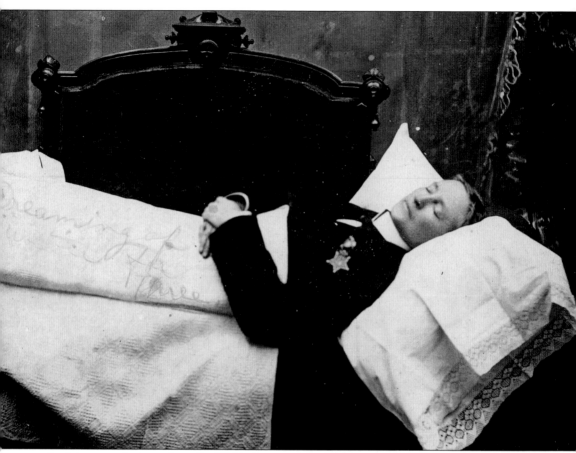

In this unusual picture from Dr. Walker's own personal belongings, "the little lady from Bunker Hill" rests at a studio. She has written on the image, "Dreaming of justice for all." That thought sums up her whole life.

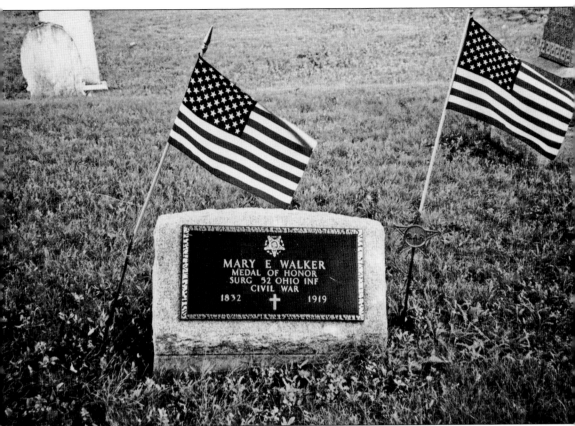

The Medal of Honor plaque marks her grave on the Walker family plot at the Oswego Town Rural Cemetery on Cemetery Road in Fruit Valley. It was placed beside the simple original granite stone that bears just her name, "Mary." The grave is attended today by the Oswego Town Historical Society and the Walker-Spencer Tent of the Daughters of Union Veterans.

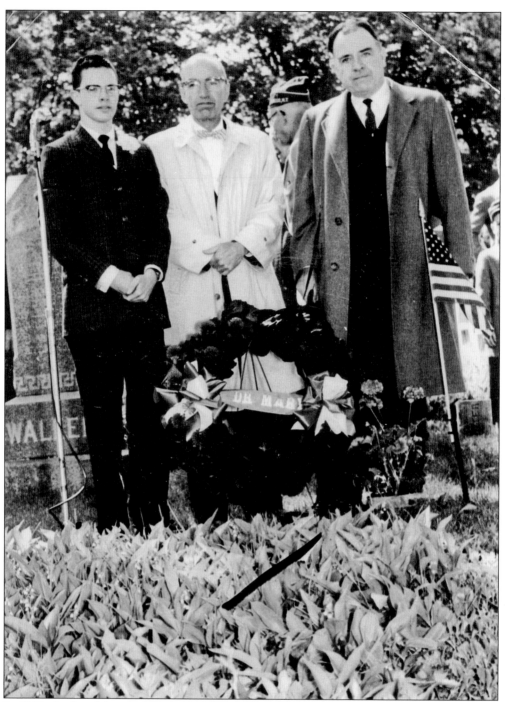

In 1961, the first Memorial Day service at Oswego Town Rural Cemetery of many years was held. From left to right at Dr. Walker's graveside are Oswego town historian George R. DeMass, Dr. Charles M. Snyder (author of the first full biography of Dr. Walker, *Little Lady in Pants*), and Francis T. Riley (chairman of the Oswego County Civil War centennial committee).

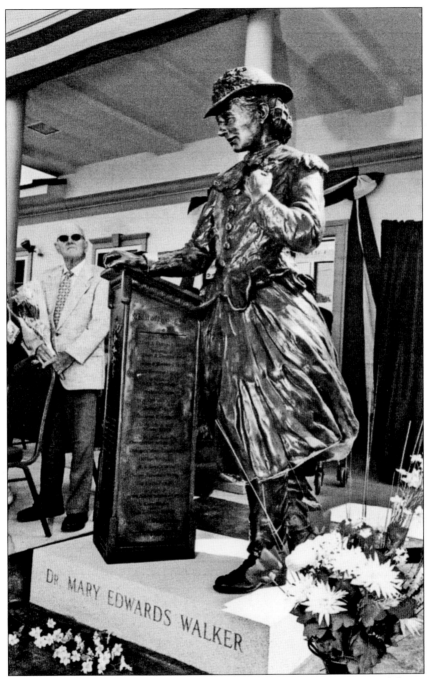

DR. MARY EDWARDS WALKER

In 2003, the Oswego Town Historical Society embarked on a project to raise a life-size bronze statue of Dr. Walker as a gift to the town. It would be placed in front of the town hall in Oswego Center. After much planning and fundraising under the leadership of Theresa Cooper, the project was brought to fruition. The life-size bronze was dedicated on May 12, 2012, in the presence of over 300 people. Sharon Bumann of central New York was the sculptor. Dr. Walker is pictured lecturing, facing the wind, which is blowing her skirt. Her hand is up to her medal, proudly showing it but also protecting it, symbolizing that it will never again be taken away.

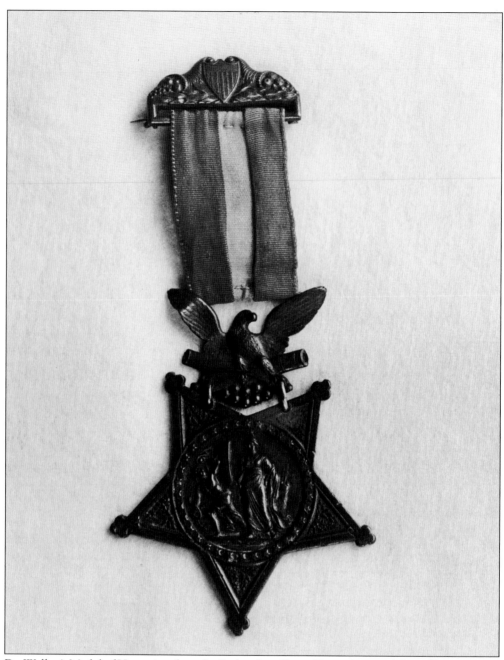

Dr. Walker's Medal of Honor is safe at the Richardson-Bates House, home of the Oswego County Historical Society. On the podium next to the statue is inscribed these words of Dr. Walker: "I have got to die before people will know who I am and what I have done. It is a shame that people who lead reforms in this world are not appreciated until after they are dead . . . I would be thankful if people would treat me decently now instead of erecting great piles of stone over me after I am dead. But then that's human nature."

Six

REST IN PEACE

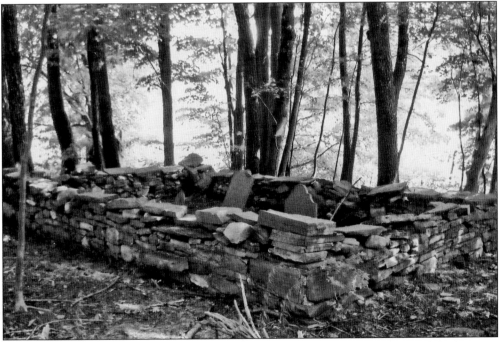

The main cemetery in the Town of Oswego is Oswego Town Rural Cemetery, established in 1820 on what was then the Brace farm. The oldest section is Old Acre. Here is the resting place of two Medal of Honor recipients, Dr. Mary Edwards Walker and Capt. James Lee, veteran of the *Kearsage* and *Alabama* battle in the Civil War. There are five cemeteries in town: Rural, Rice, Stevens, Irish Settlement, and a small family plot on the SUNY Oswego property. The oldest cemetery is the Rice Cemetery, which is pictured here. It dates to 1798 and was established by Asa Rice, the first settler. It is located in Fruit Valley.

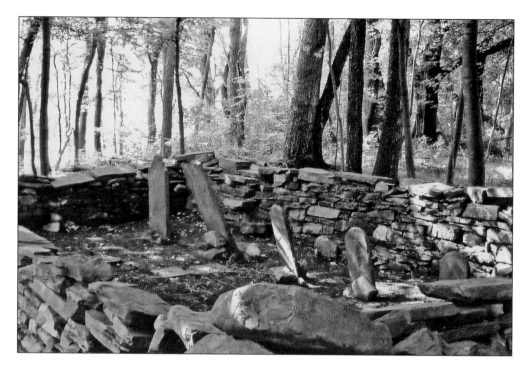

The Rice Cemetery is on the banks of Rice or Three Mile Creek. It contains members of the town's first family. The first grave is that of Asa's little son Horace, who died at about one and a half years old. The cemetery is in a secluded spot on private property. Only a few of the town's citizens know that it is there. The town hopes to feature it in its bicentennial in 2018.

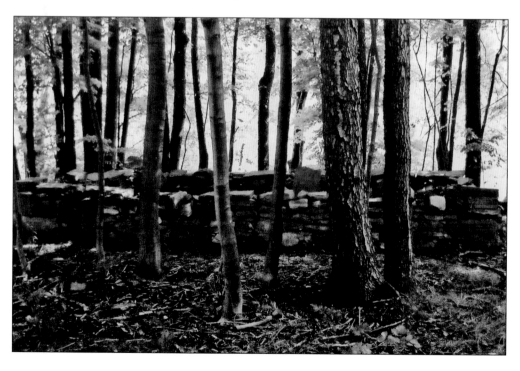

The Stevens Cemetery on Chapel Road is kept by the town and contains the graves of early settlers, including that of John E. Simmons. The family cemetery at the college is maintained by its staff.

The Old Irish Cemetery of the Irish Settlement is located on Rathburn Road and contains many graves of the early Irish immigrants. The cemetery is well kept today by the Ancient Order of Hibernians.

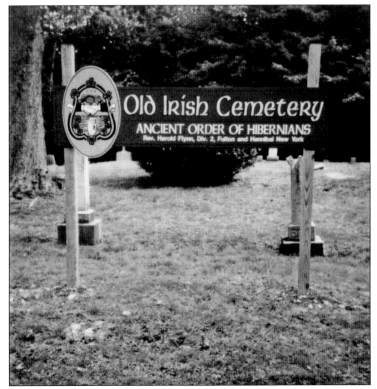

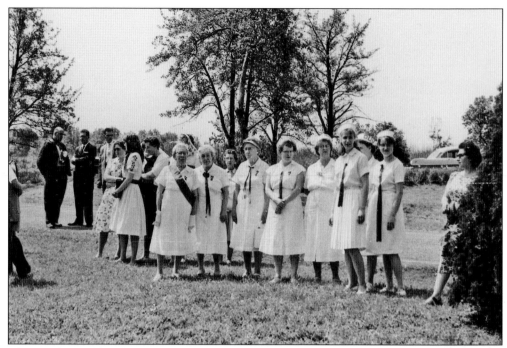

The members of the Elmina Spencer Tent Daughters of Union Veterans stand for their portrait at a Walker Memorial Day service in the 1960s at Oswego Town Rural Cemetery. The president is Beulah Brownell, standing on the left and wearing the officer's sash.

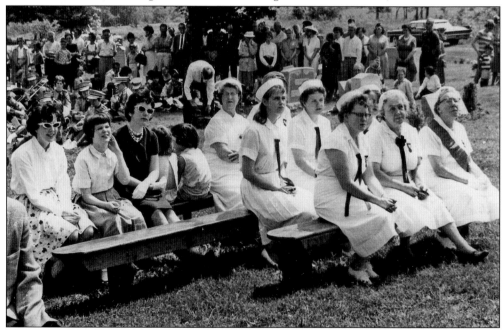

The members of the Elmina Spencer Tent Daughters of Union Veterans are seated for the program. Note the members of Hannibal Central School Band seated on the ground in the background. Sitting on the third bench, from left to right, are Martha and Meg Riley with their mother, Anne.

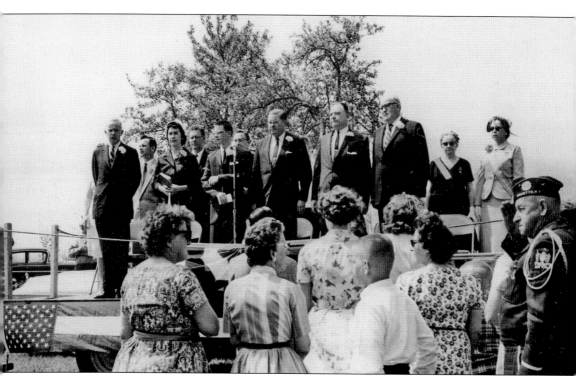

Gathered on the platform for the 1963 Walker Memorial Day service are special guests, from left to right, assemblyman Edward F. Crawford, supervisor Fred Lockwood, Grace Lockwood, Rev. Larry Draper, George R. DeMass, Father Robert Quigley, Sen. Henry A. Wise, Francis T. Riley, Joseph Farrell, unidentified, and Josephine Parkhurst.

DISCOVER THOUSANDS OF LOCAL HISTORY BOOKS
FEATURING MILLIONS OF VINTAGE IMAGES

Arcadia Publishing, the leading local history publisher in the United States, is committed to making history accessible and meaningful through publishing books that celebrate and preserve the heritage of America's people and places.

Find more books like this at
www.arcadiapublishing.com

Search for your hometown history, your old stomping grounds, and even your favorite sports team.